THE PSYCHOLOGY OF ART

Why do we enjoy art? What inspires us to create artistic works? How can brain science help us understand our taste in art?

The Psychology of Art provides an eclectic introduction to the myriad ways in which psychology can help us understand and appreciate creative activities. Exploring how we perceive everything from colour to motion, the book examines art-making as a form of human behaviour that stretches back throughout history as a constant source of inspiration, conflict and conversation. It also considers how factors such as fakery, reproduction technology and sexism influence our judgements about art.

By asking what psychological science has to do with artistic appreciation, *The Psychology of Art* introduces the reader to new ways of thinking about how we create and consume art.

George Mather is Professor of Psychology at the University of Lincoln, UK. His main research interests are in the perception of movement, art and visual illusions.

THE PSYCHOLOGY OF EVERYTHING

People are fascinated by psychology, and what makes humans tick. Why do we think and behave the way we do? We've all met armchair psychologists claiming to have the answers, and people that ask if psychologists can tell what they're thinking. *The Psychology of Everything* is a series of books which debunk the popular myths and pseudo-science surrounding some of life's biggest questions.

The series explores the hidden psychological factors that drive us, from our subconscious desires and aversions, to our natural social instincts. Absorbing, informative, and always intriguing, each book is written by an expert in the field, examining how research-based knowledge compares with popular wisdom, and showing how psychology can truly enrich our understanding of modern life.

Applying a psychological lens to an array of topics and contemporary concerns – from sex, to fashion, to conspiracy theories – *The Psychology of Everything* will make you look at everything in a new way.

For further information about this series please visit
www.routledgetextbooks.com/textbooks/thepsychologyofeverything/

THE PSYCHOLOGY OF ART

GEORGE MATHER

Routledge
Taylor & Francis Group

LONDON AND NEW YORK

First published 2021
by Routledge
2 Park Square, Milton Park, Abingdon, Oxon OX14 4RN

and by Routledge
52 Vanderbilt Avenue, New York, NY 10017

Routledge is an imprint of the Taylor & Francis Group, an informa business

© 2021 George Mather

British Library Cataloguing-in-Publication Data
A catalogue record for this book is available from the British Library

Library of Congress Cataloging-in-Publication Data
A catalog record for this book has been requested

ISBN: 978-0-367-22607-7 (hbk)
ISBN: 978-0-367-60993-1 (pbk)
ISBN: 978-0-429-27592-0 (ebk)

Typeset in Joanna
by Apex CoVantage, LLC
Printed and bound by CPI Group (UK) Ltd, Croydon CR0 4YY

For Arthur and William

CONTENTS

PREFACE

Art-making is one of the oldest known forms of human behaviour. On the other hand, the scientific process of developing hypotheses and testing them by collecting data developed, almost as an offshoot of art-making, only 500 years ago. In their own ways, both forms of human behaviour constitute quests for knowledge about the world and the place of humans in it. Despite that common cause, art and science have grown steadily apart. The inspiration behind this book was a desire to help to bring these two spheres of human behaviour closer together again by exploring the common ground that they share from the perspective of psychological science.

I have a life-long interest in the visual arts, but have spent many years of training and then teaching and researching on the psychological science of human visual perception (perhaps because I was steered away from practising visual art as a teenager at school). Our understanding of the neural processes that support human visual perception has developed rapidly over the last 50 years or so, to a point where the fundamental facts are now well established. The science is sufficiently mature to allow some fascinating dialogues to open up between art and science. After all, artists were investigating human perception long before the scientific tools to study it became available.

A broad definition of art would cover a range of disciplines including the visual arts, performing arts and literature. In the interests of simplicity and primarily brevity, the book will focus its attention on the visual arts (drawing, painting, sculpture and photography), though many of the questions and ideas discussed will also be relevant to the other artistic disciplines. Furthermore, and for similar reasons, the discussion will primarily use examples of art made in the Western tradition in Europe and the Americas.

Scientific discussions are fuelled by the theories that are developed, and the experiments performed to test them. Artistic discussions are informed by analysis of the artworks, and by the first-hand accounts of artists themselves. In this book I have placed particular emphasis on the latter wherever possible, drawn from a number of different sources.

Chapter 1 sets the scene for the rest of the book by drawing attention to the importance of art as a form of behaviour, and highlighting the shared history of art and science. It ends with a brief discussion of what we mean by art, and about the value of dividing art into '-isms'. Modern scientific knowledge about visual perception is rooted in our understanding of the brain, so Chapter 2 lays the foundations for later discussions by asking what the brain has to do with art. It also asks why scientific approaches to art are treated with scepticism by some, and surveys the most important insights that brain science offers about art. Chapter 3 asks why humans engage in art so enthusiastically. The scientific theory that underpins this discussion is Darwin's theory of evolution by natural selection, which is based on the assumption that all forms of human behaviour only persist in the population because they confer some survival advantage. The chapter discusses what possible survive advantages could accrue from engaging in art. Chapters 4 and 5 consider a set of questions about how humans create visual art. Chapter 4 concentrates on how artists depict space, contour and form, and Chapter 5 is devoted to the depiction of colour and motion. Chapter 6 turns to the crucial question of aesthetics: what makes art great? The start of the last century was a turning point for art that separated traditional approaches based primarily on

natural beauty from modern approaches based more on conceptual beauty. So the chapter considers these two periods separately. It also considers the impact of fakery, reproduction technology and sexism on judgements about art. Chapter 7, the concluding chapter, considers creativity. In particular it asks how creativity is important in both art and science, and also discusses other parallels between art and science that have been neglected, but help us to understand the close ties between the two forms of behaviour.

The book is intended as a relatively brief, accessible introduction to the psychology of art for anyone who is interested in the topic, whatever their disciplinary background. No assumptions are made about prior knowledge in either art or science, and technical terms are avoided wherever possible. Given the book's purpose, it would be inappropriate to populate it with copious academic references. However, the further readings at the end of the book guide the reader to many of the original sources, should they wish to consult them, as well as to contextual sources and videos. Wherever possible the scientific references are at the more accessible end of the spectrum, and will give the reader a route into a larger literature. Full bibliographic details of all the references are listed at the end of the book. The website www.psychologyofvisualart.com contains details of all the entries listed in the 'Further reading' section of the book, with download links where they are available. New material will also be added to the list as I discover it. The website also contains links to online collections of art that can be browsed or searched.

George Mather, April 2020

1

ART AND PSYCHOLOGY

INTRODUCTION

Art-making is a form of human behaviour that stretches back throughout recorded history. Indeed artworks such as cave paintings and sculptures often constitute the only preserved remnant of human activity. Activities associated with art have clearly been major drivers of human behaviour for millennia despite the lack of obvious and immediate benefits, unlike the rewards (such as food, safety, warmth, shelter and so on) that accrue from other forms of human behaviour. The sheer ubiquity of art through time and space begs questions about *why* humans engage so enthusiastically in such apparently unrewarding activities, and *how* they are able to produce art so profusely. These are just the kinds of questions that the discipline of psychology should be able to answer, specialising as it does in the scientific study of behaviour and the mind.

The Royal Academy of Art in London has staged a Summer Exhibition in every year of its existence. The exhibition began as a fund-raiser to support the academy's art school. Anyone can submit an artwork for display and possible sale at the exhibition. In 2018, the 250th anniversary of the academy, there were 19,800 submissions sent in from the general public, 500 of which were selected for display alongside a similar number of works by academicians. Other high-profile art shows in the UK include the BP Portrait Award, the John Moores

Painting Prize and the Jerwood Drawing Prize. Smaller scale open art exhibitions are held by local art organisations every year across the UK and all over the world. Creating and appreciating art are major leisure activities, and support a multi-billion pound professional art industry. Recent US surveys of public participation in the arts have found that about 24% of the adult population (over 57 million people) attend an art gallery at least once a year. About 12% of adult Americans take photographs for artistic purposes, and 6% (13 million people) create visual art such as paintings and sculpture. Women are more likely to engage in all of these activities than are men.

Apart from the sheer scale of exhibitions like the Royal Academy's Summer Exhibition, a casual browse through an exhibition is enough to reveal the staggering diversity of the art on display in terms of subject matter, motifs, media and techniques employed by the artists, both professional and amateur (see Figure 1.1). Nevertheless,

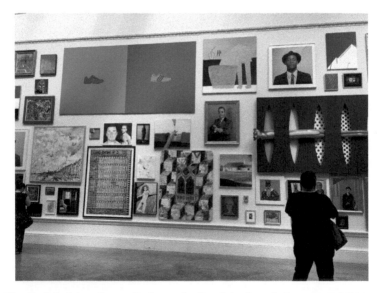

Figure 1.1 Artworks on display at the Royal Academy's Summer Exhibition in London are very diverse.

Credit line: Thanks to Sally Rodgers.

people often find it relatively straightforward to decide whether they like any particular work. Each of the selectors at the Summer Exhibition spends about a week looking at over 15,000 drawings, paintings, sculptures, photographs, videos and mixed media, and deciding which works to include in the exhibition. Each work has only a few seconds to impress the judges. Artist Grayson Perry commented in his introduction to the 2018 exhibition catalogue that "good things sailed through, and the awful were easily dismissed", though there was a large middle ground where judgements were more uncertain. Research shows that visitors to art galleries typically spend about 30 seconds looking at each artwork, so they seem to be making similarly rapid judgements about what they like or dislike. The facility with which artistic judgements are made begs more psychological questions about how we are able to appraise artworks so rapidly. It is simply incredible that humans could have evolved a specific thought process for judging the worth of an artwork, so the ease of such judgements suggests that they must tap into a more general-purpose thought process. What function might such a process serve?

WHAT CAN THE SCIENCE OF PSYCHOLOGY CONTRIBUTE TO OUR UNDERSTANDING OF ART?

Humans had been making art long before the scientific method was developed during the Scientific Revolution from the 16th to 18th centuries. Indeed, leading figures in the history of art played an important role in the development of science itself. Filippo Brunelleschi (1377–1446) was an artist, goldsmith and engineer who developed the rigorous system of linear perspective, which creates a sense of depth in pictures using real or implied lines that converge on a vanishing point at the horizon. Linear perspective allows artists and architects to create realistic depictions of three-dimensional space on a two-dimensional picture surface. Brunelleschi's perspective system lies behind the computer-generated images of 3-D scenes that are so common in modern movies and computer games. Leonardo da Vinci (1452–1519) created designs for flying machines and automatic

weapons, and dissected corpses to make some of the earliest discoveries about human anatomy, which spurred many advances in medicine. Leonardo sought to understand the world around him, so that he could better reproduce it in his art. So, the histories of art and science are intertwined. Art and science gradually grew apart as the teaching and practice of art and science become institutionalised in art academies and universities. The first art academies were established in Italy in the 16th century in Florence (1563), Rome (1573) and Bologna (1582). Although science did not exist as such at this time (the term 'scientist' is an 18th-century invention), it had a close equivalent in the form of natural philosophy, which studied nature and the physical universe. Jacopo Zabarella was the first scholar to be appointed to a position as a natural philosopher at the University of Padua in 1577. Art and science are now poles apart, both culturally and educationally, and many artists and humanities scholars resist attempts to apply scientific concepts and methods to help our understanding of art. There is a fear that science will somehow demean art, robbing it of its mystique, and usurping artists as the sole custodians of its power. For their part, scientists have under-estimated or completely disregarded the insights of artists, believing instead that the scientific method of systematic observation and experimentation is the only sound way to generate new knowledge. However, a central theme running through this book is that both artists and scientists have made and continue to generate new knowledge about the world and our place in it. Indeed their discoveries are often surprisingly coincident with each other.

Psychology as a scientific discipline arrived on the scene quite late. The mind and its relation to the body have been debated from the time of the ancient Greek philosophers, notably Plato and Aristotle. But psychology only emerged as a scientific discipline in the mid-1800s, largely due to the work of a German physicist named Gustav Fechner, who worked at Leipzig University along with other founding figures in psychology (Ernst Weber and Wilhelm Wundt). Fechner was interested in how humans make fine sensory discriminations between similar stimuli, such as two lights differing in intensity. He devised several experimental techniques for measuring the limits of

sensory discrimination; the smallest difference in magnitude between two stimuli that can be reliably detected. These techniques are called *psychophysical* techniques, because they measure the relation between mental states (sensations) and physical quantities (light intensity, mass, position, timing and so on). Fechner discovered several psychophysical laws governing the relation between stimuli and sensations. For example, he developed a mathematical formula that describes how the felt magnitude of a sensation such as the brightness of a light relates to the physical intensity of the stimulation as measured by a device such as a light meter.

More importantly for the science of art, Fechner also founded the discipline of empirical aesthetics (empirical statements are ones based on verifiable observations rather than theory or supposition). He developed new psychophysical techniques to study the relation between simple aesthetic judgements of beauty or liking and physical stimulation. One of these techniques, called the 'method of choice', is still widely used. The experimental participant is asked to compare two images, such as two artworks presented side-by-side, with respect to an aesthetic value such as 'pleasingness'. A variant of the technique involves presenting single images, rather than two together, and asking the participant to give a rating score of its pleasingness. Scores can then be analysed in relation to the characteristics of the artworks. Empirical aesthetics allows us to systematically investigate questions about whether and why certain artworks consistently provoke specific responses in viewers, particularly pleasure. However, scientific approaches can also tackle a host of other issues about art, including the brain processes engaged by art, the reasons why we make and enjoy art and whether art serves a useful purpose. All of these issues will be addressed in the coming chapters.

Before leaving this section, it is worth dwelling briefly on potential pitfalls that await us when discussing scientific approaches to art. The first pitfall is to dismiss science as unnecessary in the context of art, because we can make the same insights and reach the same conclusions based on common-sense or intuitive thinking about art. We all have beliefs or theories about the reasons for people's behaviour,

motives, thoughts and feelings. These beliefs are collectively known as folk psychology. Although some folk psychology is accurate, a lot of it is not. Later chapters will show that these two common beliefs are false:

• Human perception and memory works like a digital camera
• Creative activities like art use the right side of the brain

The best antidote to folk theories is empirical evidence. According to scientific methodology, a theory should be accepted, provisionally, only if it is not falsified by current evidence. The proviso is there because, in principle, we cannot *prove* that a theory is true, but we can show that a prediction of the theory is false. The principle of Occam's Razor is also useful when evaluating theories: 'Entities must not be multiplied beyond necessity'. All other things being equal, the best theories are those containing the fewest clauses or components, and the simplest logic. Superfluous clauses or components and overly complex logic serve only to muddy the water.

A variant of the folk psychology pitfall is to declare that a theory is simply not worthy of consideration because it is not interesting enough. For example, the philosopher Alva Noe (2011) declared that:

> What is striking about neuroaesthetics is not so much the fact that it has failed to produce interesting or surprising results about art, but rather the fact that no one – not the scientists, and not the artists and art historians – seem to have minded, or even noticed.

The criteria of interestingness and surprisingness are not ones that scientists would recognise when they evaluate theories. Indeed Occam's Razor implies that the best theories may also be the least interesting. Neuroaesthetics is discussed in the next chapter, so you will have an opportunity to decide for yourself whether this discipline has yielded any interesting or surprising insights about art.

WHAT DO WE MEAN BY 'ART'?

A simple, almost childish definition of art, at least for the purposes of this book, would be 'drawing, painting and making sculptures'. Art is traditionally viewed as a visual medium, made by a skilled hand, which is a pleasure to look at. However, since the beginning of the last century there have been continuing debates about what can be considered as an artwork. Starting with Marcel Duchamp's famous urinal, shown in Figure 1.2 (in actuality, probably created by a colleague of Duchamp's called Elsa von Freytag-Loringhoven), some artists have tried to take the question into their own hands, dictating whether something is a work of art. Their aim is to remove aesthetic considerations entirely from the definition of art and replace them with conceptual intent. In the 1960s artist Andy Warhol created artworks that were exact facsimiles of everyday objects such as Campbell's soup cans or Brillo boxes. These objects prompted many philosophers and artists to define art as anything that is accepted as such, displayed by museums and galleries and bought by collectors. So, a tin of faeces, an unmade bed or a shark suspended in formaldehyde can be declared a work of art. If that declaration receives approval, either from the art world or from the general public, then the object passes into the canon of art. Considerations of natural beauty and visual aesthetics have now become irrelevant.

The question of whether one can consider a given object as a work of art is hugely important, because the definition itself has a major psychological impact on judgements about it. Grayson Perry (2014) summarised the effect as follows:

> I need to know whether to put my art goggles on, whether I should think and feel about the work as an artwork, whether I can apply art values to it.

Museums spend a great deal of time and money designing their displays, because they affect the perception of artworks so deeply. For example, an exhibition of African art at the Centre for African Art

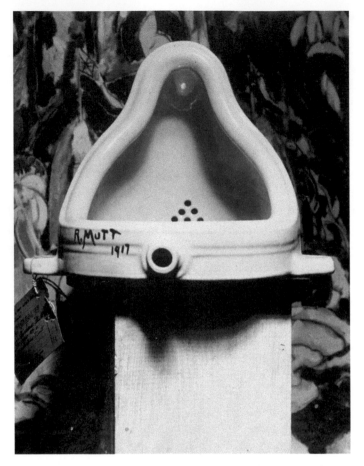

Figure 1.2 The artist Marcel Duchamp submitted a 'ready-made' urinal to an exhibition in New York City in 1917, signing it as 'R.Mutt'. It was his attempt at 'anti-art' that violated accepted criteria for what is a work of art.

in New York in 1988 explored the effect of gallery context on the perceived distinction between objects as artworks or as cultural artifacts (Faris, 1988). The way that objects were displayed affected visitor responses to them. In a 'contemporary art gallery' setting of unadorned whitewashed gallery walls, with displays under isolated pools of light,

otherwise rather banal objects take on the mysterious appearance of Modernist sculptures or constructions. In a 'natural history museum diorama' setting, complete with labels, similar objects become artifacts, and the only objects that appear to be 'art' are the constructed contextual models and the painted background scenery depicting the African plain.

Grayson Perry's 'art goggles' comment is reminiscent of an effect that is familiar to psychologists, and known as the Hawthorne effect. It refers to a change in behaviour of individuals who know that they are being observed, or are taking part in research. The Hawthorne effect is named after the Western Electric Company's Hawthorn plant in Illinois, USA, where it was first observed in a study of worker productivity during the 1920s. The study began as an investigation of the effect of lighting, monetary incentives and rest breaks on productivity. However it became apparent during the study that productivity increased simply due to the fact that workers knew they were being studied.

An equivalent effect probably influences judgements of art: Individuals alter their behaviour due to an awareness that they are observing art, or are visiting an art museum. For example, we apply different standards of judgement when we know that we are viewing an artwork rather than some random object lying in the street. Mainstream psychological laboratory research has shown that decision factors of this kind bear on *all* judgements about sensory stimulation, whether from artworks or from any other source. Psychologists working on perceptual judgements have found that even apparently simple decisions about, say, the length of a line are influenced by context, expectations and biases. Decision factors of this kind are an important part of the more complex judgements involving art, and they will crop up in a number of places in the coming chapters.

ISMS IN ART

The history of art is often presented as a series of '-isms': movements, trends, styles or theories that we use to categorise the work

of different practitioners. One type of -ism refers to a broad cultural trend, a tendency to think and work in a particular way, though individual practitioners would not necessarily recognise their own membership in a particular -ism. Romanticism is an example of this kind of -ism. It flourished in the first half of the 19th century, and infected music and literature as well as visual art. 'Romantic' art valued expressive emotion, instinct and intuition over disciplined rationalism and materialism. Its artworks were dominated by the subjectivity of feelings and moods. Prominent artists in the movement included Eugene Delacroix (1798–1863), Caspar David Friedrich (1774–1840) and Joseph Mallord William Turner (1775–1851).

Another type of -ism is defined explicitly by one or more practitioners themselves, perhaps by issuing an artistic manifesto defining their beliefs and aims. The short-lived Futurist movement began with the publication of a manifesto in a French newspaper by Italian poet Filippo Tommaso Marinetti in 1909. It was a dynamic, aggressive celebration of modern city life and technology. As one of its primary artistic exponents, Umberto Boccioni (1882–1916) stated in 1912:

> In order to make the spectator live in the centre of the picture, as we express it in our manifesto, the picture must be the synthesis of *what one remembers and of what one sees*. . . . We have declared in our manifesto that what must be rendered is the *dynamic sensation*, that is to say, the particular rhythm of each object, its inclination, its movement, or, to put it more exactly, its interior force.

His painting "Dynamism of a Cyclist" (Figure 1.3) depicted the dynamic sense of movement experienced by viewing a passing cyclist. The racing cyclist is shown moving towards the left, conveyed with force lines and reverberating curves. Other exponents of Futurism included Giacomo Balla (1871–1958) and Gino Severini (1883–1966).

A third type of -ism is a label applied retrospectively to a group of practitioners, often after they have died. This kind of -ism may be anchored in a particular period of time, or in a set of common elements in the work of several practitioners. As an example,

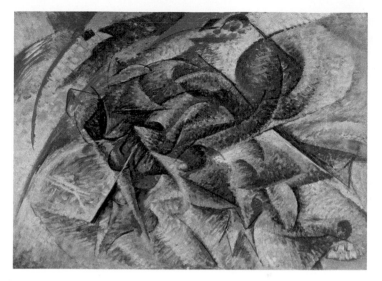

Figure 1.3 Umberto Boccioni, "Dynamism of a Cyclist", 1913.

Post-Impressionism is a broad term used to describe art produced during the years spanning the start of the 20th century, from around 1880 to 1910. The term was coined retrospectively by English critic and artist Roger Fry, in the title of an exhibition called "Manet and the Post-Impressionists" held in London over the winter of 1910. The exhibition contained work by artists including Paul Cezanne (1839–1906), Paul Gauguin (1848–1903) and Vincent van Gogh (1853–1890). Post-Impressionists shared a common desire to break away from the Impressionists' pre-occupation with the fleeting effects of light on natural scenes, and towards a focus on flattened, geometric design and structure.

-*Isms* can be criticised on the grounds that they over-simplify the rich and complex cultural and personal histories surrounding works of art. On the other hand, they constitute a form of knowledge generated by artists, art critics and historians that describes and structures a very large corpus of work in a coherent set of more understandable entities. As such, -*isms* will be an important part of later discussions in the book about the relation between artistic knowledge

and scientific knowledge. -Isms are obviously not unique to art; they also structure thinking in many other disciplines, such as philosophy (idealism, dualism, materialism, empiricism, etc.), physics (electromagnetism, thermodynamics, mechanics, relativity, cosmology, etc.) and psychology (structuralism, functionalism, constructivism, behaviourism, etc.). The ubiquitous use of -isms across many disciplines, as well as in society more broadly (capitalism, racism, sexism, ageism, nationalism and so on), is rooted in the way we think. One survey of the psychology of concepts argued that "Classification of the world around us into labelled conceptual categories is probably the most fundamental of human cognitive achievements" (Hampton, 2012). Categories such as -isms provide us with the basic cognitive tools with which we learn, reason and communicate. These tools are as useful when thinking about art as they are when thinking about any other sphere of human behaviour.

Brain science provides the bedrock of knowledge for modern psychological science, so the next chapter will begin our exploration of the psychology of art by surveying the current state of knowledge on the parts of the brain that are most relevant to art.

2

THE NEUROSCIENCE OF ART

INTRODUCTION

Prior to the 20th century, the brain was not considered to be relevant to philosophical and scientific discussions of art, and very little was known about it anyway. Artists and philosophers at the time believed that the key defining feature of art was the experience of visual beauty. One school of thought among 18th-century philosophers was that judgements of beauty are the product of rational, intellectual thought of the highest order. Another school of thought, as expressed by Immanuel Kant in particular, held that beauty is "a judgement of taste and not of the understanding of reason". Artistic 'taste' was considered to be a product of learning, and beauty was thought to be experienced as 'disinterested' pleasure (objects are judged as beautiful regardless of whether we believe them to serve our interests). This attitude to beauty found expression in the custom of sending members of the European aristocracy on Grand Tours of Italy and Greece in order to educate their sense of taste in classical artistic ideals. Ancestral palaces, castles and stately homes across Europe accumulated many examples of Greek, Roman and Renaissance art that conformed to an idealised conception of classical beauty, the spoils of Grand Tours.

The view that artistic appreciation is learnt, and that one cannot study art in isolation from culture and 'taste' (or its modern

incarnation, 'expertise') is still debated. Furthermore, the relevance of neuroscience – the scientific study of the nervous system – to our understanding of art remains contentious in some quarters. A new discipline called 'neuroaesthetics' has emerged over the last 10 years or so, prompting a lively debate about the validity of scientific approaches to art.

NEUROAESTHETICS

Over the last 60 years or so, the discipline of cognitive neuroscience has made fundamental advances in our understanding of the parts of the nervous system that are involved in cognition, which includes sensation, perception, learning, memory, attention, language, decision-making and motor control. Researchers have employed a wide range of techniques, from electrical recordings of individual neurons in the brain of a perceiving animal to whole-brain images of neural activity in the conscious human brain. Neuroaesthetics emerged as a relatively new branch of cognitive neuroscience only ten years or so ago. Researchers in neuroaesthetics study the neural mechanisms that underpin aesthetic judgements, and they have employed the full range of methods available to neuroscience; anatomical techniques (such as dyes or stains that pick out neural structures), electrophysiology (recording the electrical activity of individual neurons), neuroimaging (using X-rays or magnetic fields to visualise the structure and function of the brain) and brain stimulation (magnetic or electrical stimulation of regions in the brain). Cognition is, of course, a core area of interest in psychology, so the disciplines of cognitive neuroscience, neuroaesthetics and psychology substantially overlap. Actually, the remit of neuroaesthetics is not limited to art because aesthetic appreciation plays a role in many other contexts as well, influencing decisions about the clothes we wear, the products we buy, where we choose to live or visit on holiday, and even who we choose as friends or partners. Given that aesthetic judgements are so pervasive, and involve the interplay of a host of different factors including the characteristics of the object being judged, the individual making the judgement, and the broader context in which the judgement

is made, the underlying neural systems are complex and quite widely dispersed in the brain. So, the task facing researchers in neuroaesthetics is hugely challenging.

Some artists and humanities scholars have reacted to neuroaesthetics with scepticism, 'neuroscepticism' so to speak. Apart from the accusation that neuroscience has failed to produce interesting or surprising results about art (mentioned in the previous chapter), it has also been argued that neuroaesthetics is fraught with 'excessive reduction'. The term reductionism is used in a derogatory sense to characterise the practice of describing or 'reducing' a complex phenomenon (such as art) in terms of excessively simple (usually quantitative) constituents, and to argue that this practice is an adequate explanation for the phenomenon. It is certainly true that much of the neuroscientific research on art does deal, inevitably, in numbers. They are, after all, the common currency of science: the aesthetic preferences of viewers, activation levels in the brain and physical characteristics of artworks can all be expressed in numbers, allowing us to make unambiguous and statistically rigorous statements about the relationships between these measures. Reductionism of this kind would be a problem if the researchers claimed that these numbers alone were all that one needed to develop a settled, all-purpose, once-and-for-all account of what art is. However, many researchers do themselves acknowledge the limits of a reductionist perspective on art, and recognise the importance of considering other perspectives as well, in order to gain a full and deep understanding of art. Knowledge of the cultural context of an artwork, and of the personal history of the artist, unquestionably deepens our understanding of an artwork in a way that quantitative research cannot. Neither perspective alone can be considered the sole viewpoint from which one should ever consider art.

So, while keeping these caveats in mind, what can the scientific study of the brain tell us about art? There are two specific areas in which neuroscience has had a fundamental impact on our thinking about art.

THE CORTICAL ARCHITECTURE OF ART

The human brain is arguably the most complex and sophisticated organ in the animal kingdom, containing in total about 86 billion neurons (only about half of the number of stars in the Milky Way, contrary to the popular myth, but still a huge number). However, for our present purposes we can focus on its outermost layer containing 'just' 19% of these cells, known as the cerebral cortex. Two parts are of special interest in the context of art. One part includes several large masses of cells forming the 'reward circuit', which is intimately associated with our emotional reactions to stimulation. The reward circuit will be discussed later in the chapter.

The other part of the cerebral cortex that we need to know a little about is by far its largest part, the neocortex (often called just 'cortex'). This densely folded outer sheet of cell tissue is crammed into your skull just below the cranial bones. The cortex is closely involved in all higher cognitive functions. As it was defined earlier, cognition refers to our ability to attend to stimulation (both from the world outside and from within the body), to identify its significance and to plan meaningful responses to it. Art clearly engages all of these higher cognitive functions, so it is important to know more about how they relate to the underlying neural structures in the cortex. We first need to know more about cortical geography.

The cortex is divided laterally into two roughly mirror-symmetrical halves or hemispheres, linked by thick bands of nerve fibres (called the anterior commissure and the corpus callosum). Each hemisphere is in turn subdivided anatomically into four lobes, known as the frontal, parietal, temporal and occipital lobes (see Figure 2.1 left).

By and large, the right hemisphere receives sensations and controls actions on the left side of the body, and the left hemisphere controls sensations and actions on the right side of the body. There is a persistent idea in circulation that artists use the right hemisphere of their brain to a greater extent than the left hemisphere. The right hemisphere is also often described as intuitive, emotional and creative whereas the left hemisphere is rational, objective and analytical.

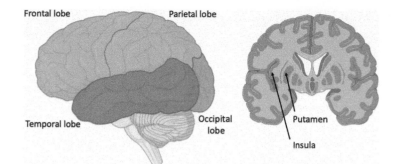

Figure 2.1 Left: The four lobes of the left cerebral hemisphere, as seen from a view of the left-hand side of the brain. Right: A vertical side-to-side cross-section through the middle of the brain, showing the locations of the putamen and insula (present in both hemispheres but only labelled in one).

Betty Edwards's well-known book *Drawing on the Right Side of the Brain*, for example, first published in 1979, promotes this view of the brain and remains a bestseller today. The idea may have taken root because some famous artists are commonly said to have been left-handed (Leonardo, Michelangelo, Raphael, Rembrandt and Picasso, to name but a few), and, as we have seen, the left hand is controlled by the right side of the brain. However, this is one area where neuroscience has led to a fundamental shift in understanding: The evidence does not back up a simple left-brain/right-brain story of art.

Firstly, to deal with the question of handedness: Does current evidence support the widespread belief that left-handedness is associated with greater artistic creativity? The question is difficult to answer definitively, because self-reported creativity and artistic practice may themselves have been influenced by the belief, and sound conclusions about handedness require very large studies (because so few people are left handed). A recent online survey of over 20,000 people (half left-handed and half right-handed) found that left-handers believe that they were more creative, but according to measurements of creativity they are no more creative than right-handers (van der Feen et al., 2019). A large-scale study of handedness in well-known artists also found no support for the

view that left-handedness is overrepresented among artists. The survey studied 500 painters from various periods of art history (Lanthony, 1995). It determined their handedness by examining portraits (excluding self-portraits) or photographs of the artists, as well as studying the direction of their hatched shading in drawings (left-handers' hatching runs from top-left to bottom-right) and searching relevant literature. Only 14 (3%) of the painters were identified as left-handed (including Dufy, Escher, Holbein, Klee and da Vinci). Another seven painters who were thought to be left-handed turned out to be right-handed (including Durer, Raphael, Michelangelo and Picasso). The incidence of left-handedness in the general population is around 9%, so this study actually found a *lower* incidence of left-handedness among well-known artists compared to the general population. The number of left-handers identified in the sample is so small that the degree of confidence that we can have in the precise percentage is limited. Even so, the study raises a question-mark over the 'left-handed artist' story.

Outside of the domain of art, clinical cases of cognitive impairment following brain damage do show that the neurons serving certain cognitive functions are located on one side of the brain only (lateralised) – in most people, speech and language are processed in the left hemisphere (in the frontal and temporal lobes), whereas neural circuits for spatial attention are located in the right hemisphere (in the parietal lobe). However, many other cognitive functions relevant to art, including creativity, are *not* lateralised in the brain. Our ability to see relies on neurons in the occipital lobes of both hemispheres. Considering your field of view as seen from each eye, everything to the left of where you are looking generates neural activity in the occipital lobe of the right cortical hemisphere, and everything to the right activates the left occipital lobe. Damage to the occipital lobe, whether through traumatic injury such as a gunshot or an infarction (a stroke, or loss of blood supply), causes some form of blindness. The blindness may result in a complete lack of any visual sensation at all, or it may be more complex, in which a specific aspect of vision is impaired while other aspects are spared. The impairment may involve specific difficulties in recognising objects, or judging colour,

movement or size. These deficiencies can necessarily have a profound effect on the production of visual art, making it very difficult for an artist to judge scale and distance, for example, or to create depictions of complex objects.

Clinical case studies demonstrate how art-making relies on the other three lobes of the cortex as well, not just the occipital cortex. Frontotemporal dementia involves degeneration in the frontal and temporal lobes. This form of dementia does not affect one's ability to see as such, but it causes a lack of self-control and an inability to plan and organise one's life. In artists, it can lead to dramatic changes in style, with disordered compositions, distortions and bizarre content. It can even prompt heightened interest in art, and apparently enhanced artistic creativity, in patients having little previous interest in such activities. As mentioned earlier, the right parietal lobe is particularly important for spatial attention. Damage in this lobe causes a condition called unilateral spatial neglect, in which the patient fails to respond to events or objects that appear on the left side of space, and almost seems to deny the existence of the 'left'. Artists suffering from this condition ignore one half of their canvas, and tend to neglect the left-hand side of objects that they attempt to depict in their work, even when they are very familiar with them, such as in self-portraits. Unilateral spatial neglect can afflict even highly skilled and experienced artists; it is not a condition that can be overcome by an act of will.

Consistent with the clinical literature, and in contrast to the widely believed left-brain/right-brain dichotomy, recent research shows that the processes of artistic thinking and creativity involve two large-scale networks of cells that are widely and bilaterally distributed across the frontal, parietal and temporal lobes. Each network includes an interconnected group of cortical areas that seem to function together as a unit during particular mental activities. One network is called the Default Mode Network (DMN). It was first discovered when neuroimaging researchers observed surprising levels of coordinated activity across particular cortical regions when experimental participants were not asked to engage in any specific task at all, but were resting

(hence the label as a 'default mode' of brain activity). The DMN is active during self-generated thoughts such as reflection and mind-wandering. The network includes areas in the frontal, parietal and temporal lobes, as well as a region lying on the inside surface of the cerebral cortex called the posterior cingulate cortex. The other network is called the Executive Control Network (ECN), which is well known to be active during externally generated attention to tasks that require the coordination of short-term memory, mental flexibility and self-control. The ECN includes areas in the frontal and parietal lobes. The areas included in the two networks are illustrated in Figure 2.2.

Research shows that both the DMN and the ECN are active while we engage in art related activities. A neuroimaging study of art students engaged in sketching out ideas for a book cover design (Ellamil et al., 2012) found that these two networks operate in a coordinated way. The DMN was dominant while participants were generating new ideas for sketches, as one might expect of a network that is active

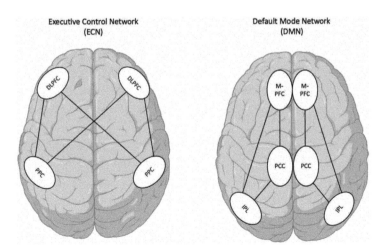

Figure 2.2 Two views looking down on the top of the cerebral cortices, showing the areas in the Executive Control Network and the Default Mode Network. DLPFC: Dorsolateral prefrontal cortex. PPC: Posterior parietal cortex. M-PFC: Medial prefrontal cortex. PCC: Posterior cingulate cortex. IPL: Inferior parietal lobule.

during periods of reflection in which one's thoughts are directed inwards. The ECN became more active while participants were evaluating their sketches. It seems that during evaluation, a considerable degree of control is exerted by the ECN in order to focus attention, integrate information and select an appropriate response. Another study also found that the DMN is activate when people make highly positive aesthetic ratings of artworks (Vessel et al., 2012).

The involvement of these two large, functionally and anatomically complementary cortical networks in the generation and evaluation of artistic ideas demonstrates how art really does give all of our cognitive functions a full work-out. No cortical lobe is spared from involvement in the artistic process, which is far richer and more complex than that implied by the old left-brain/right-brain account of artistic creation.

AESTHETIC PLEASURE AND THE BRAIN

The second important breakthrough in our understanding of art made possible by studies in neuroaesthetics concerns the nature of aesthetic pleasure. As outlined at the start of the chapter, traditional philosophical attitudes to beauty consider it to be a higher intellectual judgement, perhaps entirely culturally determined. Studies of brain activation carried out whilst people make aesthetic judgements reveal a different story.

A consistent finding is that the same few brain structures are activated when people view paintings or make aesthetic evaluations of images: the orbitofrontal cortex, the anterior insula, the amygdala and the putamen. Figure 2.1 (right) shows the locations of the insula and putamen. These structures form part of the so-called 'reward-circuit' in the brain, which is well-known to play a role more generally in the neural processing of basic emotions or 'core affects' and future rewards. Core affects are universal feelings of pleasure or displeasure in response to objects that

are helpful or harmful, rewarding or threatening (Barrett et al., 2006).

The reward circuit's role is thought to involve converting

> disparate types of future rewards into a kind of internal currency,
> that is, a common scale used to compare the valuation of future
> behavioural acts or stimuli (Montague & Berns, 2002).

These alternative activities and stimuli generate all of the pleasures and pains that humans experience, including eating, making love, fighting, meeting friends and so on.

The involvement of the reward circuit in our experience of art is a highly significant finding, because it means that judgements of art are not set apart on a higher intellectual plane than other judgements, as implied by traditional philosophical attitudes to aesthetics. Art provokes basic emotions just like other human pleasures. Basic emotions are thought to be hardwired, universal and automatic. They presumably evolved to help our ancestors survive the many ecological challenges that early humans faced. The finding that art activates the reward circuit begs the question of how art can have survival value. The next chapter will discuss some possible answers to this question.

3

WHY DO WE ENGAGE IN ART?

INTRODUCTION

As mentioned in the first chapter, engagement with art is a universal behavioural trait among humans. Why is art so widely enjoyed? According to Charles Darwin's theory of evolution by natural selection, each individual in a human population has behavioural traits that are slightly different from everyone else's, due to re-combinations and mutations in their genes at conception. Individuals whose particular traits make them better equipped to survive and reproduce are more likely to pass on those traits to their offspring. So selected traits gradually accumulate over many generations to produce individuals who are supremely well-adapted to survive. Eyes offer a particularly pertinent example. Sensitivity to light has huge survival value, because it can provide rapid and highly detailed information about the immediate environment. Even a pessimistic estimate of the span of time needed to evolve an organ as complex as the human eye is as short as 400,000 years.

At first sight it might appear that Darwinian evolution has little to tell us about art. Artworks are among the most intellectual, complex and diverse of all human achievements. They are highly personal, particular and expressive, unlike, say, a spider's web (however beautiful). Nevertheless, although artistic practice is a hugely complex form of human behaviour, that does not mean it should be immune from the

influence of evolution. Darwin himself foresaw the relevance of evolution to psychological questions. In his book *The Origin of Species* he wrote:

> In the distant future, I see open fields for far more important researches. Psychology will be based on a new foundation, that of the necessary acquirement of each mental power and capacity by gradation.

However, the relevance of evolution to art is still controversial. The cognitive scientist Steven Pinker argued in 1997 in his book *How the Mind Works* that art is a by-product of other adaptations, rather than an adaptation in itself. In his view, a toolbox of evolved general-purpose cognitive capabilities

> can be used to assemble Sunday afternoon projects of dubious adaptive significance.

In Pinker's decidedly dismissive view, art is something that the human species engages in during its 'days off' from the main business of survival. But what exactly are 'by-products of adaptations'? Non-adaptive side consequences of adaptations were called 'spandrels' by the evolutionary biologist Stephen Jay Gould, after the triangular architectural spaces on the inside walls of a building, left where rounded arches or windows meet a dome or ceiling. These spaces are the by-products of the arches or windows; they are a side consequence rather than a deliberate feature. Gould claimed that the human brain is full of spandrels; they account for "most of our mental properties and potentials".

In his book *The Art Instinct* (2010) the philosopher Denis Dutton disagreed with dismissals of the arts as non-adaptive, arguing that we should be taking their possible adaptive functions more seriously:

> The explanatory power of evolutionary psychology lies foremost in identifying adaptations. But its job can also include explaining

the character and features of any persistent human phenomenon, in part or in whole, by connecting it to properties of adaptations.

When thinking about the possible adaptive origins of any form of behaviour, including art, it is helpful to distinguish between *ultimate* and *proximate* explanations.

ULTIMATE AND PROXIMATE EXPLANATIONS OF BEHAVIOUR

The distinction was first made by Nikolaas Tinbergen in 1963. Tinbergen was a Dutch ethologist (specialist in the study of animal behaviour) who won the Nobel Prize in 1973 for his discoveries about the causes of animal behaviour (the prize was shared with his colleagues Karl von Frisch and Konrad Lorenz). According to Tinbergen, any form of behaviour can be understood both at an ultimate level and at a proximate level. An explanation at the ultimate level is concerned with the functional benefits of the behaviour; in other words, *why* that form of behaviour was selectively preserved during the process of evolution; what is its survival value. On the other hand, a proximate explanation is concerned with the mechanisms that support the generation of the behaviour; in other words, *how* that behaviour is actually produced and sustained.

Although Tinbergen's distinction between ultimate and proximate explanations was developed from studies of animal behaviour, it has also made an important contribution to the study of human behaviour. A specific example will help to make the argument clearer. Most people like to eat chocolate. The ultimate explanation for this behaviour is an evolved, genetically transmitted nutritional need to consume sugars and fats. Proximate explanations for eating chocolate would include the physiological mechanisms that signal hunger, and activation of reward circuits in the brain when sweetness receptors in the mouth respond to sugar-rich foods. Other ultimate and proximate factors may also be involved in chocolate eating behaviour. Ultimate

factors could include an evolved need to bond socially with others by sharing your chocolate, in order to increase survival chances, or to display your ability to gather resources for a potential mate. These factors may in turn be associated with other proximate causes such as cultural practices around food-sharing and gift-giving customs. So innate, adaptive predispositions even for relatively simple behaviours like eating chocolate can be modified or constrained by an array of different cultural rules and meanings.

A fundamental theoretical issue for art-making is whether it can be considered as an evolved predisposition in itself, and therefore open to ultimate explanations. In this chapter we will consider some plausible ultimate explanations of art, and then begin to evaluate proximate influences on artistic practice.

ULTIMATE (WHY) EXPLANATIONS OF ART

What possible evolutionary advantages of art-making as a behavioural trait could lead to its selective preservation in ancestral human populations? Comparative studies of animal behaviour suggest two plausible ultimate explanations for art as an adaptation in itself. One explanation argues that art is adaptive as a form of play that improves our ability to survive environmental challenges. The other explanation argues that art-making originated as a way to attract mates.

ART AS A FORM OF PLAY

Art may have evolved as a way to practice and develop some important physical and cognitive abilities. Artistic practice hones the creative, imaginative and physical skills needed to make new objects, and the cognitive and emotional skills that help us to cope with unexpected and potentially harmful events, all of which would improve our survival chances in a challenging environment. There are plentiful examples of play in animal behaviour, which can take the form of locomotor play (play-fighting, exploration), social play (hunting,

food-sharing) and object play (construction and manipulation of objects). A surprisingly wide range of animals appear to engage in play. Apart from higher mammals such as primates, animals including spiders, lizards, fish and crocodiles also 'horse around'. The ubiquity of play among animals supports the idea that it serves a useful adaptive function of the kind suggested here. However, play behaviour in animals peaks during adolescence, and does not form a part of the adult behavioural repertoire (unless the adult is playing with an adolescent of course). On the other hand, art-making most definitely is in the behavioural repertoire of adult humans, mostly in the absence of children. An obvious riposte to this argument is that human adults engage in many other forms of playful behaviour, such as game-playing, so why not consider art as adaptive play? However, the defining features of play behaviour as an adaptation do not fit well with a play theory of art-making. Playful behaviour is not serious and fully committed, but instead is a rather simplified and weaker form of adult behaviour, such as play-fighting. The means are more important than the ends of the behaviour. The founder of the Olympics, Baron Pierre de Coubertin, said,

> The most important thing in the Olympic Games is not winning but taking part; the essential thing in life is not conquering but fighting well.

However, elite athletes and sportspeople are highly competitive and take their sport extremely seriously. They have a drive to win whatever the personal cost. Art-making too is taken very seriously indeed by many artists, and the end-product is critical to the successful execution of the behaviour. Indeed art-making is highly competitive, as mentioned in the next section.

ART AS A FITNESS INDICATOR

Darwin proposed that certain physical characteristics in an individual serve as 'fitness indicators' that attract mates and deter rivals. These

traits do not, according to Darwin, necessarily enhance the individual's prospects of survival, but they do enhance their prospects of passing on their genes to the next generation. Indeed, the strongest sexual fitness indicators may be those that challenge survival prospects most severely because only the fittest individuals are able to survive and mate while bearing the cost of creating and maintaining them. This is Darwin's explanation for certain extravagant physical characteristics such as the displays of plumage in male birds. The ocelli or eye-spot markings on the tail feathers of peacocks were so beautiful to Darwin in their three-dimensional appearance, including a reflected highlight, that in his view the peahen's mate choice amounted to an aesthetic preference.

In many animals, fitness indicators extend beyond bodily characteristics to embrace behavioural tendencies. For example, male wheatear birds carry heavy stones from the ground on their wings, and place them in cavities in cliffs to demonstrate their health status to females. Male fiddler crabs build a small mud pillar next to their burrow to increase their attractiveness to females. In some species, these indicators arguably have aesthetic qualities. Male sticklebacks decorate their nest entrance with contrastingly coloured algae, and females prefer more ornamental decoration designs. Male bowerbirds in New Guinea and Australia have a uniquely aesthetic way of attracting mates. Each male builds a 'bower' or boudoir, and then decorates it with carefully arranged collections of found objects. The brightly coloured decorations each bird assembles can include shells, leaves, stones, insect carapaces, berries or feathers, each in its own pile. Colour choices seem to reflect the preferences of females, who visit a number of different bowers to watch the owner's courtship display and assess the quality of the bower. A number of females may select the same mate, while other males are passed over completely.

These and other examples of fitness indicators in animals inspired the aesthetic fitness hypothesis, which proposes that art-making evolved through the competitive process of sexual selection, as a trait that signals the genetic quality of individuals who are able to create such costly displays. Art-making is indeed very costly. Artworks are

frequently made of rare or expensive materials such as silver, gold, marble and rare mineral dyes. They are often very time-consuming to create, and require a great deal of skill (that is itself time-consuming to acquire). Artists are also well known to be quite competitive with each other, as one might expect in a fitness contest. Famous rivalries can be found throughout the history of Western art. In 14th-century Florence, Filippo Brunelleschi and Lorenzo Ghiberti were bitter rivals. They submitted competing designs for the doors of Florence's Duomo, and the wool merchants who commissioned the doors found it difficult to decide between the two. Brunelleschi and Ghiberti were asked to work together on the doors, but Brunelleschi refused. This event led to a continuing feud between the two artists during the subsequent design and construction of cathedral's dome or cupola. About 100 years later in the same city, the two leading artists of the time, Leonardo da Vinci and Michelangelo, became direct competitors and bitter rivals during the painting of two walls in the Council Hall of the Palazzo Vecchio. Only fragments of the two artists' works survive, though the story of their rivalry is still vividly told by art historians. Artistic rivalries are not unique to Renaissance Florence. In 19th-century England there was a famous rivalry between J.M.W. Turner and John Constable, and at about the same time in France the country's two great artists, Eugene Delacroix and Jean-Auguste-Dominique Ingres, were fierce adversaries. Famous artistic rivalries in the 20th century include disagreements between Vincent van Gogh and Paul Gauguin and between Pablo Picasso and Henri Matisse.

Competitiveness is by no means unique to art of course. It can be found in all kinds of human behaviour, and probably has an evolutionary source. So, one cannot regard the existence of artistic rivalries as strong evidence in itself for the fitness theory of art. At the very least, artistic rivalries demonstrate that the practice of art is not immune from the competitive urges selected by evolution. More specific evidence for art as a fitness indicator has come from studies that have investigated the sexual behaviour of artists. The fitness theory predicts that artists should have more success in this area than non-artists. Surveys of artists (of both sexes) have found that

those who successfully produce art have larger numbers of sexual partners than those who are less successful, or do not engage in artistic activities (Clegg et al., 2011). We cannot be sure, of course, that art-making itself is *causal*; that is, it causes people to be more attractive. It could be that other factors correlated with art-making, such as creativity, influence attractiveness.

Sigmund Freud recognised that sex was closely connected to art-making, but his psychoanalytic theory of art was couched in terms of sexual drives and symbolism. According to Freud, art is a form of sublimation, a self-defence mechanism in which socially unacceptable urges are transformed into acceptable actions:

> [the artist] longs to attain honour, power, riches, fame, and the love of women; but he lacks the means of achieving these gratifications. So, like any other with an unsatisfied longing, he turns away from reality and transfers all his interest, and all his libido, on to the creation of his wishes in his life of fantasy.

Note the implicit assumption that artists are male. Freud interpreted Leonardo's paintings of smiling women as representations of his mother from his childhood. Psychoanalysis does not bear close scrutiny as a scientific theory, though it was arguably the first of the 'talking therapies' that are still widely used. The core concepts of psychoanalytic theory are hard to define and measure, and have been challenged and refuted by a great deal of evidence.

So far, we have considered two ultimate explanations of art as an adaptation in itself: It may have originally evolved due to its adaptive value as 'play', or through its role in sexual selection. It is possible that the function of art-making began in this way, but was then significantly modified or extended during evolution. This kind of shift in function is called 'exaptation'; an adaptation that co-opts or builds on a previous adaptation. Feathers, for example, are thought to have evolved initially as an adaptation for temperature regulation, but this earlier structure was later exapted or co-opted to serve a new function as well (flight). We now consider two possible co-opted roles for art.

ART AS A FORM OF EMOTIONAL EXPRESSION

The physiological and behavioural characteristics of emotions ultimately evolved because they enhance our ability to cope with and respond to challenges and opportunities. For example, when a predator is in close proximity, the physiological changes that accompany feelings of fear and panic put the individual in a heightened state of readiness to escape as fast as they possibly can: The release of epinephrine overcomes fatigue, blood is re-routed to support maximum muscle exertion, respiration rate increases to increase exchanges of oxygen and carbon dioxide in the lungs, and so on.

As outlined in Chapter 1, emotional expression is one of the defining features of art. So, a plausible adaptive account of art-making derives from a possible function as a means to express the emotional state of the artist. The testimonies of artists themselves are consistent with the idea that emotional expression is a defining feature of art. Francis Bacon's paintings often provoke feelings of distaste and dislike among gallery visitors. The people in his paintings often look distorted, despairing and in pain. Some critics have interpreted the emotions expressed in Bacon's work in terms of his homosexuality, or the traumas he experienced during the Second World War (he was declared unfit for active service but worked for Civil Defence, recovering the dead after air raids). Bacon himself argued that his work was purely about painting. However, he declared in 1952 that:

> [Art is a] method of opening up areas of feeling rather than merely an illustration of an object. . . . I am just trying to make images as accurately as possible of my nervous system as I can.

Bacon admired Vincent van Gogh and Pablo Picasso deeply, and made repeated reference to their work in his own. Both of these artists saw emotional expression as central to their work. According to Pablo Picasso in 1935:

> The artist is a receptacle for emotions that come from all over the place: from the sky, from the earth, from a scrap of paper, from a

passing shape, from a spider's web. . . . A painter paints to unload himself of feelings and visions.

The abstract artist Kasimir Malevich, instigator of the Suprematist abstract art movement, stated in 1927 that:

To the Suprematist, the appropriate means of representation is always the one which gives fullest possible expression to feeling as such and which ignores the familiar appearance of objects.

The consistent statements by artists themselves about the emotional power of art lend plausibility to the idea that a core feature of art is the way that it communicates information about the emotional state of the artist.

ART AS SOURCE OF KNOWLEDGE

Many animals constantly seek knowledge about the world around them, gathered largely by exploring their immediate environment. They are instinctively curious. Humans also harbour a burning desire to know and understand the world. This thirst for knowledge seems to be independent of any immediate external rewards, as if it were reinforcing in itself. Curiosity or knowledge-generating behaviour is assigned a value in the neural reward system, as described in the previous chapter. Ultimately, the thirst for knowledge can be explained as an evolved trait that maximises fitness in uncertain and rapidly changing environments.

The pace of human knowledge-generation sped up during the Scientific Revolution 500 years ago, driven on by our instinctive curiosity and our ability to reason and build causal models of events. Science is now arguably the preeminent source of new knowledge. However, knowledge-generation is not unique to science. Art-making may also be a product of our insatiable curiosity. Indeed as outlined in the first chapter, prior to the Scientific Revolution no distinction was made between knowledge-generation in science and in art. There are

many plausible parallels between the knowledge generation as practiced by artists and by scientists, though these parallels have largely gone unnoticed. A number of them are discussed later in the book.

The philosopher Nelson Goodman argued that art expands our understanding of the world and meets some of the same criteria as successful scientific hypotheses: clarity, elegance and rightness. Both art and science create worlds that seem right in relation to our needs and habits. The artist Paul Klee commented in 1920 that:

> Art does not reproduce the visible; rather it makes visible. We [artists] reveal the reality that is behind visible things. . . . Things appear to assume a broader and more diverse meaning, often seemingly contradicting the rational experience of yesterday.

These comments could equally have been made by a scientist investigating the physical and chemical properties of objects, or the neural processes by which humans recognise and manipulate objects. As we shall see in the next chapter, the work of Modern artists in particular has attempted to depict the psychological reality behind visible things; how we *see* the world. Knowledge generation is a core feature of art in the modern era. Artists lie at the centre of the art world, creating and transmitting knowledge to the public at large through the various art institutions (academies, museums and galleries) and modern media. Artists are often called upon to comment on current social, political and scientific issues. Artists act as political commentators, and activists for social or environmental issues. It is also worth noting that art has been used for centuries as a powerful medium for the dissemination of political and religious propaganda.

PROXIMATE (HOW) CAUSES OF ART

So far in this chapter we have considered some of the roles that art may play in several different forms of adaptive behaviour, including play, fitness signalling, emotional expression and knowledge generation. These functions are not mutually exclusive. It may

be the case that art initially evolved for one function, but later took on other adaptive functions. Layered on top of these ultimate, evolutionary causes are a host of mechanisms that shape the way that art is expressed: the complex influences of culture, society and cognition, some of which encompass the intellectual and creative environment that affects everyone, and others are unique to each artist's personal history. This section briefly discusses some broad socio-cultural factors governing artistic expression, and the next chapter will consider another group of psychological causes; the cognitive mechanisms by which art is expressed.

Artists and their artworks are immersed in the general intellectual and creative environment generated by culture, that affects everyone in it. So, a full understanding of the form, content and meaning of artworks requires an appreciation of the cultural and social context within which they are expressed. These influences can be considered among the proximal causes of art. One of the artistic -isms defined in Chapter 1 relates specifically to broad cultural trends. Nineteenth-century Romanticism, for example, valued individual emotion and intuition over reasoning and logical thought. It influenced all of the arts, including visual art (painters such as J.M.W. Turner, William Blake, Theodore Gericault and Caspar David Friedrich), music (Pyotr Ilyich Tchaikovsky, Johannes Brahms, Gustav Mahler) and literature (Lord Byron, William Wordsworth, Percy Bysshe Shelley). Some art movements are quite short-lived. The Fauvist movement of the early 20th century lasted only three or four years. Broader cultural influences on art can extend over much longer periods of time.

In cultures based on a rigid social hierarchy, with strict adherence to rules, visual art tends to adopt well-ordered, conventional, rigid and stereotypical forms. Ancient Egyptian art does not attempt to depict depth or distance, or the layout of objects in a scene (see Figure 3.1). The same drawing system persisted for almost 3,000 years. Objects were arranged in a flat picture plane along lines drawn on walls. Objects and their parts were observed with great precision, but depicted in a way that conveyed shape in the most simplified manner. In human figures the torso was drawn from the front, but

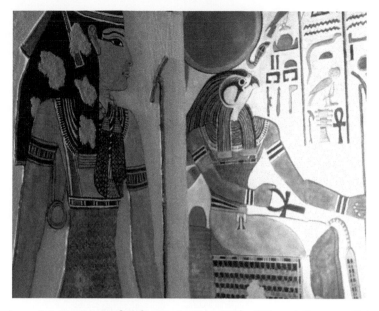

Figure 3.1 The tomb of Nefertari, the Great Wife of Pharaoh Ramesses II, in Egypt's Valley of the Queens.

the head, waist and limbs were drawn in profile. Medieval artists revived the Egyptian reluctance to record the natural world faithfully, favouring instead depictions of the human form that conform to a strict formula involving expressionless, flat figures without individuality. This system of depiction was driven by religious concerns to avoid glorifying the attributes of individuals and their unique viewpoint on the world. There was little attempt to portray realistic depth, and the depicted stature of figures tended to reflect their social status.

In cultures having more egalitarian principles based on reason and logic, art displays much more realism. The ancient Greeks initially studied and imitated the Egyptians in their own 'kouros' statues of young men. These archaic forms emphasised geometric purity over anatomical accuracy and realism. In the later classical period of Greek sculpture, the purpose of their sculpture shifted dramatically towards

realism and naturalism. The aim was to take into account the actual shape and form of an individual body in a natural pose. The period of Enlightenment in Europe witnessed the re-birth (renaissance) of ancient Greek ideas in artistic depiction. The old Medieval rules and systems were replaced with ones that fully acknowledged individuality in form, expression and viewpoint. In Giotto di Bondone's "Birth of the Virgin" fresco in the Cappella degli Scrovegni, Padua, painted around 1303 (Figure 3.2), the figures have some individual identities and expressions, and are placed in a recognisable three-dimensional space. The rigorous system of linear perspective perfected during the later Renaissance period gave a precise, mathematically pure expression to the idea that art should depict the world from the viewpoint of the individual.

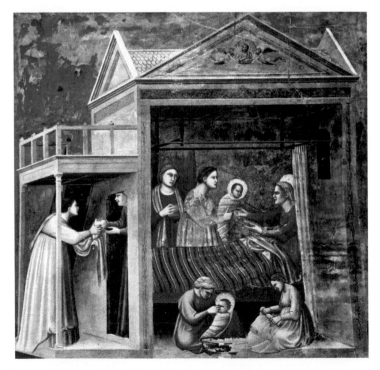

Figure 3.2 Giotto di Bondone, "Birth of the Virgin", c. 1303.

So some general characteristics of art can be understood in terms of its socio-cultural context, but such sweeping generalisations cannot obscure the contribution of individual artistic genius in all cultures, such as the ancient Greek sculptures of Praxiteles, who created the much-copied statue of Aphrodite, or the life-like, expressive frescoes painted by Giotto in the late medieval period.

SUMMARY

Another quote from philosopher Denis Dutton sums up much of the debate in this chapter about the relevance of evolution to art:

> Darwinian explanation is always looking back into the past to adaptations that come to us from the ancestral environment, but then also toward the effects of history and culture on how evolved adaptations, strictly conceived, are modified, extended, or ingeniously enhanced – or even suppressed – in human life.

Art may have evolved as an adaptation (a form of play, a fitness indicator) and/or been co-opted as another adaptation (emotional expression, knowledge generation). These functions are not mutually exclusive. Evolution is widely accepted to be an opportunist process, co-opting traits for new uses in order to exploit opportunities for enhanced fitness as and when they arise. Not only are different ultimate causes of art likely to interact, but different proximate causes may also combine to create the huge complexity and diversity that is the signature of art.

4

DEPICTING SPACE, CONTOUR AND FORM IN ART

INTRODUCTION

From the 15th century to the 20th, the primary occupation of Western visual artists was in creating realistic depictions of the world around them, simulating a view through a window. In 1568, the Italian painter and historian Giorgio Vasari commented in his book *Lives of the Artists* that:

> Design is the imitation of the most beautiful things in nature, used for the creation of all figures whether in sculpture or painting; . . . the artist achieves the highest perfection of style by copying the most beautiful things in nature and combining the most perfect members, hands, torso, and legs, to produce the finest possible figure for use in all his works; this is how he achieves what we know as fine style.

During the Renaissance period and for hundreds of years afterwards, artists were preoccupied with the question of how to create art that imitated nature in the most vivid and beautiful manner possible. In this quest for naturalism, they made many discoveries about human perception that often anticipated the scientific discoveries of the 19th and 20th centuries. Artists learned how to create a convincing sense

of depth and space on a two-dimensional picture surface; which colour combinations are most pleasing to the spectator; how to model form and shape in paint; and how to convey dynamic action in a static image.

Paul Cezanne remarked in 1904 that:

> being a painter, I attach myself first of all to visual sensation. . . . Painting by means of drawing and colour gives concrete shape to sensations and perceptions.

More recently, the artist Robert Pepperell (2017) argued that artists

> have tended to address the subjective aspects of human perception, i.e. the phenomenal experience of seeing the world.

Psychologists since the late 1800s have had much the same aspiration as artists: to understand how we perceive three-dimensional space and shape, infer the colour of surfaces and interpret the movement of objects. Visual artists explore sensation and perception in their artistic practice of drawing, painting and sculpting, whereas scientists do so through collecting data in experimental studies. In this chapter we will consider both artistic and scientific knowledge about the visual depiction of space, contour and form. In the next chapter we will consider the depiction of colour and motion.

DEPICTING SPACE

A fundamental aspect of almost all visual experiences is the sensation of space. The three-dimensional world appears to stretch out before our eyes, we see objects as solid bodies, arranged on or above the surfaces in view. The optical properties of the human eye clearly play an essential role in building our sense of space. The eye has some design features in common with a camera: A lens system gathers light from the external world and projects it onto the inner surface of a dark chamber ('camera' means chamber or room in both Latin and Italian).

The spatial pattern of light and dark formed inside the chamber is a two-dimensional projection of the three-dimensional scene outside. In a digital camera, the inner surface of the chamber contains a rectangular matrix of solid-state photosensitive picture elements (pixels) that register the amount of light falling on each location. The inner surface of the eye, known as the retina, also contains a matrix of light-sensitive elements, in this case the elements are specialised photoreceptor cells that each register the incident light at that retinal location. Each photoreceptor sends an electrical signal to a network of neurons lining the retina. So, at first sight the characteristics of the retinal image seem to be a good place to start if we aim to understand how our sense of space is created by the brain. However, the optical retinal image itself is not very impressive. It is very small; if you look at a credit card held at arm's length in front of you, its retinal image would be about 2.3 mm wide and 1.45 mm high (less than half the size of the image cast on to a full-frame camera's sensor or film by a standard 50 mm lens). The image is also quite distorted compared to a camera's image due to the curvature of the eye-ball, and extremely unstable. Each time we make an eye movement (in other words, two or three times every second) the entire image slides rapidly across the surface of the retina. A more fundamental problem with the analogy between a camera and the eye is that we do not actually store and perceive retinal images in anything like the way that a camera records the images that fall on its sensor. We are not aware of images inside our eyes. Instead, we see a stable and predictable world of coherent surfaces and solid objects, out there in front of our eyes. The brain constructs and maintains a rich and stable internal representation of the visual world that is far removed from the distorted, transitory patterns of light that flit across the retina. All of this happens literally in the blink of an eye, with no conscious intervention. The formidable task of the artist is to find a way to depict this sense of space without having direct access either to the retinal image on which it is based or to the hidden neural processes that convert the image into perception. However, certain aspects of our visual experience offer the observant and perceptive artist some clues about effective depiction.

NATURAL (ANGULAR) PERSPECTIVE

Since the time of the ancient Romans, and probably before, artists have known that the angular size of an object at the eye carries information about its distance from the spectator. Figure 4.1 illustrates the concept of angular size. It shows an eye in cross-section viewing the same painting from two different distances. The vertical height of the painting defines one side of an imaginary triangle. The other two sides of the triangle meet at the spectator's eye to create an angle. This angle, measured in degrees, defines angular size. In this case it specifies the height of the painting in degrees. The painting's width can also be measured in terms of its angular size, using a corresponding triangle. Figure 4.1 demonstrates that from the perspective of the spectator's eye, the angular size of the painting diminishes in proportion to its distance. Although the objective size of the painting remains fixed, its angular size at the eye is smaller when it is farther away (compare the solid and dashed lines). In general, angular size halves with each doubling in object distance. Psychological research has shown that angular size is used in natural human vision as a way to estimate the distance of an object from the viewer.

Leonardo da Vinci called the effect of viewing distance on projected angular size 'natural perspective'; it can also be called 'angular perspective'. Prior to the Renaissance, artists used simple local rules

Figure 4.1 Natural or angular perspective: The angular size of an object at the eye depends on (1) the actual size of the object and (2) its distance from the spectator. The near painting subtends about 50 deg, whereas the far one subtends only 25 deg even though they are the same actual size.

or heuristics based on natural perspective to convey a sense of depth in their pictures. The rules were local in the sense that they were applied to relatively small parts of the painting at a time. More distant objects and people were depicted as smaller, apart from people of higher social status who were painted as taller regardless of depth. Lines receding in depth away from the viewpoint of the spectator were generally painted at an oblique angle. The application of these techniques can be seen in the work of one of the foremost painters in the 14th century, Giotto di Bondone (see Figure 3.2 on page 36). Under careful scrutiny, the depth depicted in Giotto's "Birth of the Virgin" is not quite consistent with a single viewpoint. Instead, different parts of the scene have different viewpoints. For example, the relatively high angle from which the bed is viewed is not consistent with the inclination of the floor surface of the room itself. The viewpoint of the two women standing in the doorway is different from the viewpoint of the room interior (the bed is too close to the doorway and is not visible through it). Such inconsistencies are a common feature of paintings that rely on local heuristics to depict depth in different parts of the scene. In some artworks this variation in local depth may be a deliberate choice of the artist, perhaps because the work is intended to depict a montage of different events or scenes. This may well be the case in Giotto's fresco painting; the infant Mary appears twice in the painting.

In his *Treatise on Painting*, Leonardo da Vinci described how to create a much more coherent and convincing depiction of depth from the perspective of a spectator. His description still cannot be bettered:

> Perspective is nothing else than seeing a place [or objects] behind a pane of glass, quite transparent, on the surface of which the objects which lie behind the glass are to be drawn. They can be traced in pyramids to the point of the eye and these pyramids are intersected by the glass pane.

The window in question has become known as 'Leonardo's Window' or 'Alberti's Window', as illustrated in Figure 4.2. The "point of

Figure 4.2 Linear perspective demonstrated using Leonardo's Window.

the eye" upon which all lines converge is also called the 'centre-of-projection', and is located at the nodal of the eye, inside the lens. Once the tracing on the glass plane is complete it would be possible to remove the objects themselves and as long as the spectator's eye remained in precisely the same viewing position, the view of the traced projection would exactly correspond with the view of the objects themselves.

ARTIFICIAL (LINEAR) PERSPECTIVE

During the Renaissance, Filippo Brunelleschi and Leon Battista Alberti developed a rigorous and geometrically precise system of linear perspective for constructing a depiction of the depth in an entire scene so that it appeared consistent with a single viewpoint, just as illustrated in Leonardo's Window. The system uses straight lines and triangles, constructed according to the principles of Euclidean geometry, to create the projection without the need for tracing on transparent windows, as long as one had a ground plan of the shape

and disposition of the objects to be depicted, and the position of the spectator (centre-of-projection). Artificial linear perspective was a major advance on natural perspective because it provided a mathematically rigorous system for depicting an entire three-dimensional scene, rather than local rules of thumb about how angular size changes with distance.

Modern technologies for depicting or recording visual scenes (cameras, computer algorithms and so on) create linear perspective projections. But many artists, art theorists and historians have argued that linear perspective is in some sense 'artificial' or 'incorrect'. For example, the distinguished art historian Erwin Panofsky stated that:

> perspective construction as practiced in the Renaissance is, in fact, not 'correct' from a purely naturalistic, that is a physiological or psychological point of view (see Pirenne, 1952).

He also argued that linear perspective is a 'symbolic form' similar to writing, that one must learn to interpret. Objections to linear perspective centre on crucial three issues:

1 The retina of the eye is curved, not flat, so a projection created on a flat plane is not appropriate for the eye.
2 Linear perspective is accurate only when the picture is viewed from the projection's centre-of-projection.
3 We sometimes experience straight lines as curved, whereas they are always depicted as straight in linear perspective projections.

Let's consider each of these objections in turn from the perspective of psychology and neuroscience. It is true, as stated in the first objection, that the retina is curved rather than flat, so that the retinal image is always curvilinear. However, the shape of the retina is not relevant to the perspective projection system demonstrated by Leonardo's Window. Linear perspective just simulates or constructs the bundle of rays that would converge on the nodal point of the lens from a specific three-dimensional scene, as if the spectator were standing in that

scene. It has nothing to say about the shape of the imaging surface behind the lens. The destination of the bundle of light rays after they pass through the lens is not relevant to the accuracy or otherwise of the process that created the bundle of rays.

Turning to the second objection, it is also true that a linear perspective picture is an accurate simulation of a three-dimensional scene only if it is viewed from the centre-of-projection. All other viewpoints introduce some degree of distortion because the projection is not viewed centrally but obliquely to one side or another. Since linear perspective has only one centre-of-projection, strictly speaking a linear perspective projection should only be viewed with one eye rather than two. Despite these apparent restrictions, spectators are quite tolerant of viewpoint, and find that linear perspective pictures look acceptable from a range of different viewpoints. Why is that? One possibility is that the distortions are so small that they are not noticeable to most viewers. Another is that the visual system has an automatic compensation mechanism for correcting this kind of image distortion, that is normally applied to oblique views of objects in order to achieve shape constancy. If the rectangular shape of the picture frame is visible, the visual system may normalise the perceived shape of the picture so that it appears rectangular, correcting any distortion of the picture in the process (Vishwanath et al., 2005).

Actually, on close inspection it is possible to find departures from linear perspective even in paintings that appear to use the system quite rigidly. These departures appear to be designed to minimise distortions caused by viewpoints away from the centre-of-projection. For example, Raphael's "The School of Athens" (Figure 4.3) seems at first sight to adhere very closely to the principles of linear perspective. The lines defining the three-dimensional architecture of the space converge on a single vanishing point located between the hips of the two figures at the centre of the composition (representing Plato and Aristotle). One characteristic of images created using linear central projection is that shapes near the extreme edges of the frame are distorted. A sphere positioned near the bottom right-hand corner of the frame, for instance, becomes an ellipse in the projected image;

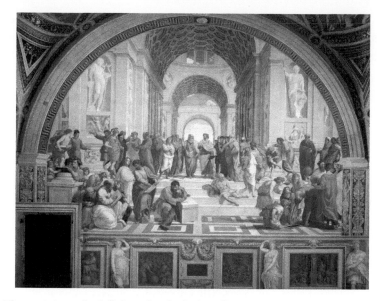

Figure 4.3 Raphael, "The School of Athens", 1511.

the long axis of the ellipse points towards the vanishing point in the centre of the picture. When the spectator views the picture from the centre-of-projection, the ellipse is correctly projected as a sphere, because in their slightly sideways view of the edge of the picture the ellipse is foreshortened back into a sphere. But when the spectator is positioned closer to the right-hand edge of the frame, the sphere's distorted elliptical shape may become apparent. Two spheres are actually present near the bottom-right corner of Raphael's composition, held by two of the figures. But the spheres, and all the figures nearby, are drawn without any perspective distortion and therefore violate a strict application of linear perspective. Perhaps Raphael wanted to depict the impressive building itself as a coherent and well-structured three-dimensional space, but also wanted the people and objects in it to appear natural and undistorted at all viewing positions. This is a key point that leads on to the discussion of the third objection: Artists are not necessarily interested in complete geometric accuracy.

The third objection was that straight lines in the world often appear to be curved. This objection is also true. Long lines in particular can indeed appear to be curved, but this does not mean that we should completely abandon linear perspective as a method of creating perspective projections in favour of curvilinear perspective. Linear perspective simply delivers a bundle of rays to the nodal point of the eye's lens; it does not make any assumptions about whether any lines that are specified in the bundle of rays will *appear* to be straight or curved to the viewer. It may well be the case that very long lines in a large linear perspective picture will appear curved to a spectator positioned at the centre-of-projection. This apparent curvature is worthy of scientific investigation in itself, but it does not invalidate the projection system that produced the lines.

Curved contours are sometimes used in artworks to convey the apparent curvature of straight lines that is often apparent in wide-field views; straight lines become curved, flat surfaces appear bulged. It is wrong to argue, as some scientists have, that this is misguided, and that artists should only ever employ linear perspective because it is geometrically accurate. Artists are generally interested in depicting their visual experience, not in creating geometrically accurate pictures. That experience may naturally include subjective curvature in straight lines, as well as changes in the apparent size or shape of objects.

So, neither linear perspective nor curvilinear perspective can claim to be the 'correct' way to depict space in pictures. The most appropriate choice of projection system depends on the artist's intent. Linear perspective can claim geometrically accurate imagery, if that is the aim, but curvilinear perspective may be more appropriate when the intention is to depict our subjective experience of space.

Renaissance linear perspective played a central role in James J. Gibson's influential psychological theory of 'direct' perception, first published in 1950. His theory identified some features of the sensory information arriving at the eye that correspond directly to

specific useful properties of the environment, which Gibson called 'affordances':

> The affordances of the environment are what it offers to animals, what it provides or furnishes for good or ill (Gibson, 1950).

For example, he proposed that graded changes (gradients) in object size and texture density in the retinal image are very informative about the depth and layout of the surfaces within view. If you are looking at a bank of pebbles on a beach, for instance, the projected angular size of the pebbles at your eye declines progressively as their distance from you increases. The rate of decline specifies the steepness of the bank. Gibson relied heavily on the mathematical system of linear perspective projection to supply the calculations that are central to his theory. However, he made no mention of the relation between his theory and the development of linear perspective by Renaissance artists. Indeed, Gibson cited only a book on perspective by William R. Ware, a professor of architecture in the School of Mines at Columbia College, USA, published in 1900. This book, in turn, did not cite the origins of the system in Renaissance art. So this close link between artistic knowledge and scientific theorising in perception has not been fully appreciated. The parts of Gibson's theory that originate in the Renaissance and relate to the information content of projected images have made the most significant contributions to theories of perception, and to the algorithms in computer vision systems. On the other hand, Gibson's ideas about how the brain picks up the information in images have been superseded by modern information-processing models in which the brain builds mental models of the visual world.

CONTOUR AND FORM

The first step in rendering a visual form or shape such as a face in a picture is usually to mark out its contours, features and edges. However, Leonardo da Vinci made the acute observation that sharp lines

and edges do not really exist in our retinal images, only blurred lines and edges:

the eye does not know the edge of any body.

Blur is an unavoidable physical characteristic of all optical images, including those formed on the retina of the eye. Most keen photographers will be aware that the extent of blur present in an image depends on the quality of the lens and its depth-of-field given the diameter of the entrance aperture. In order to convey the blurred, indistinct edges defining shapes in natural images, Leonardo used an oil painting technique called 'sfumato'. For example, in the profile of Mona Lisa's cheeks and chin there is an imperceptibly smooth transition from the darkness of the background to the smooth, light skin of her cheek. 'Sfumato' is the past participle of the Italian verb 'sfumare', meaning to soften or dissolve. The technique was first developed by Flemish oil painters such as van Eyck and van der Weyden. It involves building up many layers of translucent paint, mostly containing just the oil medium with tiny amounts of pigment, to soften or dissolve the underlying details of the painting.

In some areas of Leonardo's paintings the transition in tone across an edge is so gradual that one would be hard-pressed to say where the border lies between two regions or shapes. When computer scientists in the 1970s and 1980s were developing early artificial-intelligence computer vision systems to detect and identify shapes and objects captured in camera images, they discovered that it was surprisingly difficult to get past the first step in the process, finding edges, mostly for the reason that Leonardo had identified and depicted hundreds of years before; edges are often so indistinct that they are virtually impossible to detect. A second problem for computer edge-finders is that, even when an edge is found it may not be a useful edge; some edges are much more important than others. Any given edge in an image may represent something important like the bounding contour of a meaningful shape, or it could be a transitory and relatively unimportant consequence of a shadow falling across a shape. This

distinction is quite difficult for a computer algorithm to make reliably, but not so difficult for brains.

The visual system is, of course, very adept at finding the important edges in images. The process starts in the retina with neural 'edge-finder' circuits that respond strongly where lightness changes from dark to light over a short distance, or vice-versa, but relatively weakly where lightness changes much more gradually. The essential role that edges play in visual perception is clear from the long history of line drawings in art, which stretch back through centuries. The first line drawings date back to cave paintings at least 30,000 years old. Research shows that line drawings are identified as quickly and as accurately as photographs, probably because lines trigger neural responses in the edge-finder circuits described earlier that evolved to deal with natural scenes (see Sayim & Cavanagh, 2011).

In a clear and intentional break with the Renaissance sfumato technique that blurs edges, Post-Impressionist painters placed particular emphasis on the edges of shapes, often marking them with thick, dark lines as if to highlight or exploit the spectator's facility for finding edges. This style, known as cloisonnism, was also used by Japanese print-makers. Van Gogh was heavily influenced by Japanese prints, and said in 1888:

> I try to grasp what is essential in the drawing – later I fill in the spaces which are bounded by contours either expressed or not, but in any case felt – with tones which are also simplified, by which I mean that all that is going to be soil will share the same violet-like tone, that the whole sky will have a blue tint.

The Post-Impressionists also generally did not depict shadows or shading in their art, as conveyed in this remark by Paul Gauguin, also in 1888:

> Besides I consider Impressionism as a completely new quest which must necessarily separate itself from everything mechanical like photography, etc. That is why I will get as far away as

possible from that which gives the illusion of a thing, and since shadows are the *tromp l'oeil* of the sun, I am inclined to do away with them.

Gauguin's remark was made at a major watershed period in art history, when figurative art began to move away from creating paintings that 'gave the illusion' of things. Up to that point, most artists had strived to create highly convincing and realistic depictions of the world, incorporating perspective projection, blurred edges, shading, shadows and so on. Indeed the Realist art movement led by Gustave Courbet was at its peak during the mid-1800s. Such realistic depictions of objects and scenes from the viewpoint of the spectator were (and still are) very difficult for artists to achieve successfully, because sensory and perceptual processes always intervene. Our perceptions of the objects in any given visual scene depend not only on the content of the image itself, but also on the knowledge that we have acquired about the context of the scene. Knowledge about the characteristic size, shape, colour, texture and meaning of the objects influences our perception of them. So if, for example, we see a plate or a coin on a table top, we tend to judge its projected shape from the perspective of our viewpoint as more circular than it really is in the image, because we know that plates or coins are circular. A similar bias applies to judgements of size. For these and other reasons, artistic depictions of scenes may depart from strict projective accuracy. Traditionally, artists aiming for projective realism have used aids such as optical devices (mirrors, camera obscuras), linear perspective constructions or grids.

However, as Gauguin's remark indicates, the advent of photography in the 19th century led artists to raise fundamental questions about their role in creating visual depictions. Prior to photography, art was the only way to create and preserve realistic and accurate visual records of objects, scenes and people. Living in the 21st century, it is very difficult for us to imagine what life would be like without photographic imagery. Once a loved one had died, or an object or building was destroyed, our subjective record of their visual

appearance would gradually and inevitably fade from memory. Artistic depictions that preserve appearance were only available to the few people who possessed the skill to make them, or the wealth to pay an artist. Monarchs, generals, rich patrons, examples of human beauty, grand palaces, cities and natural wonders were captured for posterity in artworks produced by the most skilled artists of the time. But in the late 1800s photography usurped artists in this role, and realistic photographic depictions of visual appearance became commonplace.

Artists began to recast their role as seeing *beyond* the mere appearance of things, because that was now available in photographs. Their goal was to see into the mind of the spectator, and to depict their sensations and experiences in art. In pursuing this goal, artists had insights about perception that anticipated the scientific theories that emerged later in the 20th century. Paul Cezanne commented in 1904:

> Being a painter I attach myself first of all to visual sensation. . . . Painting by means of drawing and colour gives concrete shape to sensations and perceptions.

Paul Klee remarked in 1920:

> We [artists] reveal the reality that is behind visible things. . . . Things appear to assume a broader and more diverse meaning, often seemingly contradicting the rational experience of yesterday.

Beginning with the Post-Impressionists, Modern art left behind traditional, almost photographic, artistic depictions of depth, shape, shading and perspective, favouring instead flattened depth and cloisonnism. All of these characteristics can be seen in Paul Cezanne's "Still Life with a Ginger Jar and Eggplants" (Figure 4.4). At a deeper psychological level, they also developed theories about the process of perception. Artists such as Cezanne, Braque, Picasso and Gris believed

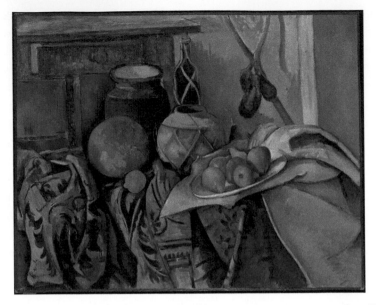

Figure 4.4 Paul Cezanne, "Still Life with a Ginger Jar and Eggplants", c. 1893.

Credit line: The Metropolitan Museum Public Domain.

that there are certain ideal 'basic forms' with which the mind represents objects. Cezanne said in 1904:

> Deal with nature by means of the cylinder, the sphere, and the cone.

Real-word forms were explicitly depicted in their paintings using simple geometric shapes such as cones, cylinders, cubes and planar quadrangles, as can be seen in Figure 4.4. Cubism was at the vanguard of this revolution in visual depiction. The art historian and collector Daniel-Henry Kahnweiler commented in 1915 that:

> In its works, Cubism, in accordance with its role as both constructive and representational art, brings the forms of the physical

world as close as possible to their underlying basic forms. . . . The unconscious effort which we have to make with each object of the physical world before we can perceive its form is lessened by Cubist painting through its demonstration of the relation between these objects and basic forms.

Cubist paintings tried to depict multiple viewpoints or perspectives of the same object in a single image, while Futurist paintings tried to depict the same objects at multiple time points in a single image. Remarkably, these Modernist ideas connect directly to, and largely anticipated, later scientific theories about how objects are represented in the brain. As far as I am aware, the scientists who developed the theories were not inspired by the ideas of artists. Scientific theories of object perception actually proposed that the brain represents objects in terms of a limited number of basic forms or parts, echoing Cezanne's forms. According to the computational theory of 'structural descriptions' developed by Marr and Nishihara in 1978:

> A shape representation does not have to reproduce a surface's surface in order to describe it adequately for recognition; as we see here ['pipe-cleaner' figures], animal shapes can be portrayed quite effectively by the arrangement and relative sizes of a small number of sticks (Marr & Nishihara, 1978).

The theory uses structured collections of cylindrical parts to represent object shape. A later psychophysical theory known as 'recognition-by-components', or RBC, proposed that objects are represented in the brain by a small set of geometric component parts including blocks, cylinders, wedges and cones (Figure 4.5). The presence of these parts in an image is, the theory argues, signified in an image by five 'readily detectable properties': curvature, collinearity, symmetry, parallelism and co-termination. So, a cylindrical form, for example, can be detected by the presence of two parallel edges (its sides) and two curved edges (its ends). Other theories of object representation in the brain have more in common with Cubist representations of multiple object facets

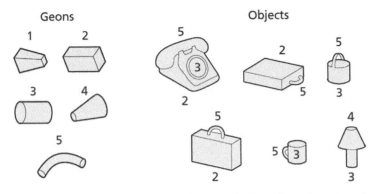

Figure 4.5 A selection of Biederman's geons (left), and combinations that form objects (right).

Credit line: From Biederman (1987). Copyright © American Psychological Association.

in a single image. They propose that the brain represents each known object not as a structured collection of its parts, but as a small collection of typical pictorial views of the object. A regular three-dimensional form such as a house, for instance, could be stored in terms of just two or three lateral views that include the front, side and rear aspects. All other views that one is likely to encounter are intermediates between these prototypical views. There is experimental evidence to support both parts-based and view-based theories of object recognition (see Hummel, 2013). Both changes in the angle of view of an object, such as a rotation, and changes in the visibility of its parts can affect the ability of spectators to recognise the object. It seems that the visual system may use a combination of both kinds of representation. So, ideas about visual experience that guided the earliest Modern artists at the very start of the last century have much in common with theories of object representation in the human brain that were developed by psychologists and computational neuroscientists towards the end of that century.

BEYOND BASIC FORMS

The first abstract paintings in Western art appeared in the second decade of the last century. By definition, these works of art contain

no recognisable real-world forms. As the French writer Appollinaire said in 1912:

> While the goal of painting is today, as always, the pleasure of the eye, the art-lover is henceforth asked to expect delights other than those which looking at natural objects can easily provide.

The following quotes illustrate some of the varied materials that abstract artists have used for inspiration.

Stuart Davis in 1945:

> In 1927–28, I nailed an electric fan, a rubber glove and an egg-beater to a table and used it as my exclusive subject matter for a year. The pictures were known as the 'egg beater' series and aroused some interested comment in the press, even though they retained no recognisable reference to the optical appearance of their subject matter.

Joan Miro in 1947:

> They [a group of gouaches made in 1940] were based on reflections in water. Not naturalistically – or objectively – to be sure. . . . I even used some spilled blackberry jam in one case as a beginning; I drew around the stains and made them the centre of the composition.

Jean Dubuffet took random printed impressions ('empreinte') from many natural materials. In 1957 he wrote:

> the images strewn on the floor . . . evoke fast-moving beings, or meteors, with a most fantastic effect; others, on the contrary, exempt from anything which might evoke beings, depopulated, but creating richly adorned surfaces like the depths of the sea or great sandy deserts, skins, soils, milky ways, flashes, cloudy tumults, explosive forms, oscillations, fantasies, dormitions or murmurs, strange dances, expansions of unknown places.

It is clear that, although abstract artists aim to avoid complicating or contaminating responses to their art with the knowledge, meaning and memories invoked by real-world forms, they are nevertheless often inspired by the spatial qualities – forms, textures and tones – that they discover in natural scenes. Pablo Picasso declared in 1935:

> There is no abstract art. You must always start with something. Afterward you can remove all traces of reality. There's no danger then, anyway, because the idea of the object will have left an indelible mark. It is what started the artist off, excited his ideas, and stirred up his emotions.

Figure 4.6 shows a preparatory study for the final abstract painting called "Composition VII" by Vassily Kandinsky. The composition

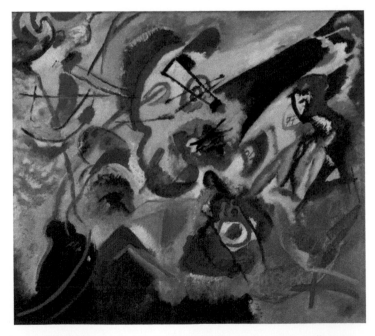

Figure 4.6 Vassily Kandinsky, "Fragment 2 for Composition VII", 1913.

is thought to be based on biblical themes such as the Deluge and Last Judgement, expressed in abstract forms that were reminiscent of landscapes and figures but transformed and simplified to such an extent that they become unrecognisable, though still convey the 'feeling' evoked in Kandinsky by nature.

Jean Dubuffet was a particularly acute observer of the qualities that could inspire his abstract art. He said in 1957:

> For there is a key to natural mechanisms, just as what happens in a grain of sand or a drop of water exactly reproduces that which happens in a mountain, or an ocean – aside from scale, aside from the rate of speed which vary. As a painter I am an explorer of the natural world and a fervent seeker of this key. Eager, like all painters, I think, perhaps like all men, to dance the same dance that all of nature dances, and knowing no greater spectacle than to take part in that dance. . . .
>
> Burn scale! Look at what lies at your feet! A crack in the ground, sparkling gravel, a tuft of grass, some crushed debris, offer equally worthy subjects for your applause and admiration.

The art critic Waldemar Januszczak once said while viewing an abstract drip painting by Jackson Pollock: "I could be looking down a microscope, or up at the cosmos".

These quotes highlight an affinity between abstract art, natural visual forms and visual perception that transcends the notion of basic geometrical shape. The mathematician Benoit Mandelbrot observed in 1982 that:

> Clouds are not spheres, mountains are not cones, coastlines are not circles, and bark is not smooth, nor does lightning travel in a straight line.

He was referring to a property of natural forms known as 'scale-invariance' or 'self-similarity'. A self-similar pattern is one that repeats at different spatial scales; a small piece of the pattern looks

the same as a much larger piece. For instance, a fern looks the same whether one views an entire branch or a very small part of the branch. As Mandelbrot described, many natural forms possess this property: branches in snowflakes, blood vessels, trees and river systems; or the jagged outline of small rock fragments, cliff faces, entire mountain ranges or coastlines. He called this kind of pattern 'fractal', from the Latin word *fractus* meaning fragmented or broken, because the pattern can be broken down into ever smaller parts that look the same. Mandelbrot developed a mathematical system called fractal geometry to measure the self-similarity in many natural forms. Self-similar fractal patterns can be created using very simple rules for repetitively accumulating new elements into the pattern. This is the process by which many natural forms develop and grow. Self-similarity is such a universal characteristic of natural forms and their images that neural pathways in the visual system of the brain seem to have evolved populations of cells that respond optimally to this characteristic. Different groups of cells pick up information at different spatial scales in the retinal image, reflecting the range of scales found in natural images.

Intuitive artistic knowledge of visual self-similarity is evident in the preceding quotes, and in many artworks. The Victorian art critic, writer and artist John Ruskin gave a precise description of how to make a fractal tree pattern in his book *Modern Painters* in 1902:

> Assume, for example's sake, the stem to separate always into two branches, at an equal angle, and that each branch is three-quarters of the length of the preceding one. Diminish their thicknesses in proportion, and carry out the figure any extent you like.

Ruskin provided an illustration of a tree constructed according to this procedure (see Figure 4.7). His procedure is basically a recipe for creating a simple fractal pattern. The smallest branches of the tree conform to exactly the same pattern as the trunk.

One of the most famous images in art, Katsushika Hokusai's "The Great Wave off Kanagawa", c. 1829 (Figure 4.8b), has a self-similar quality in the sense that the leading edge of the breaking wave is

Figure 4.7 John Ruskin's drawing of a tree made using his simple rule.

Figure 4.8a Katsushika Hokusai, "Fast Cargo Boat Battling the Waves", c. 1805.

Figure 4.8b Katsushika Hokusai, "The Great Wave off Kanagawa", c. 1826.

defined by smaller waves, and those waves in turn are defined by even smaller waves. An earlier, less successful version of his image was lacking in this self-similar quality (Figure 4.8a). The addition of waves upon waves achieved the more natural, impressive effect that Hokusai sought.

One element of the pleasure we experience in certain self-similar artistic images may relate to the way that they optimally stimulate the neural pathways in the brain that are tuned to this characteristic of natural images. The fractal properties of Jackson Pollock's drip paintings, for example, have been studied very closely and are claimed to reflect fractal properties of natural patterns. However, mathematical analyses of samples of Modern art paintings indicate that this artform has increasingly explored motifs that diverge quite markedly from those that match natural scenes. Perhaps this diversity itself reflects an intuitive artistic rejection of motifs that evoke the material world, as part of a broader trend in Modern art to downplay the importance of traditional visual pleasure as a desirable property of art.

5

DEPICTING COLOUR AND MOTION IN ART

DEPICTING COLOUR

There was a long-running debate in 16th-century Italy over the relative merits of design and drawing (*disegno*) versus colour (*colore*) in art. The tradition of art in Florence at this time emphasised the use of drawings and preparatory studies (cartoons) prior to painting. Drawing was seen as an essential skill for a well-rounded artist who could paint, sculpt and design, and was central to artistic training (Michelangelo and Leonardo excelled in all of the disciplines, and left many examples of their skill). It is no coincidence that linear perspective, based on drawn constructions, was devised in Florence. On the other hand, artists in 16th-century Venice such as Titian and Tintoretto were inclined to skip preparatory studies and paint in colour from the outset of a painting. This inclination stemmed from a uniquely Venetian tradition of rich coloration in marble, mosaic and paint, made possible by the city's trade with territories that could supply the necessary raw materials such as minerals and pigments. No doubt the uniquely Venetian light created by the watery and often foggy environment also contributed to the growth of this tradition. Venetian artists used oil paint as opposed to tempera because it coped better with the damp conditions. The debate was partly an expression of Italian civic rivalry between Florence and Venice. But it also

exerted a significant influence on art education and on the history of European art in the succeeding centuries. Titian's late 'magic impressionist' style anticipated the 19th-century Impressionist movement.

The facility with which artists can work in these two completely separate modes of expression, monochromatic and polychromatic, is probably a reflection of the multiple neural pathways carrying information about the visual world through successive layers of analysis in the brain. Information about form and colour is segregated in two distinct pathways, beginning in the retina and persisting at least as far as the early stages of processing in the cortex. So we are able to make sense of images that are completely devoid of colour, including monochrome drawings, photographs and television transmissions. The monochromatic 'form' pathway can extract much more spatial detail than the 'colour' pathway. Hence colour can be applied quite loosely to a line drawing without affecting its appearance.

THE PHYSICS OF COLOUR

Colour literally adds a new dimension to a monochrome artwork, but before discussing how artists use colour, some basic facts about colour will help to avoid some confusion. Light travels as a wave of electromagnetic energy that vibrates at right-angles to the direction of travel, like waves on the surface of water. Just like any other wave, light undergoes reflection, refraction and diffraction when it encounters obstructions. This allows lenses to form images. A very narrow range of wavelengths (distance between wave peaks between 400 and 700 nm; 1 nm is a billionth of a metre) evokes visual sensations, and the colour we experience when light strikes the retina depends on the mixture of wavelengths that make up the light, though in a very complex manner. Most light sources emit a broad spectrum of wavelengths: The spectral composition of daylight consists of many different wavelengths above about 450 nm, whereas LED panels mostly emit light in the range 400–500 nm. Most surfaces consistently reflect some wavelengths and absorb others. This property is known as a surface's 'spectral reflectance': Tomatoes and berries almost always reflect light

wavelengths above 600 nm and absorb shorter wavelengths, whereas leaves reflect primarily in the region below 600 nm. Colour vision is thought to have evolved because it helps us to discriminate between objects on the basis of their spectral reflectance. The colour that we experience when we look at a surface represents the visual system's estimate of the surface's spectral reflectance. It seems to be an intrinsic property of the surface. The computations required to estimate surface spectral reflectance are extremely complex because they must take into account both the spectral composition of the illuminating light and the spectral reflectance of the surface.

PRIMARY AND SECONDARY COLOURS

Artists commonly draw a distinction between 'simple' or 'primary' colours and 'secondary' colours. Primary colours are in some sense the purest, most elemental of all colours whereas secondary colours are intermediate between or mixtures of the primaries. But it is perhaps not surprising given the complexity of colour that artists have often disagreed on which colours fit into the two categories. In the late 15th century, Leonardo da Vinci did not settle on a fixed number of primary colours, though he had initially identified six of them:

> The simple colours are six, of which the first is white, although some philosophers do not accept white or black in the number of colours, because one is the cause of the colours and the other is the absence of them. However, because the painter cannot do without them, we place them in the number of the others, and we say that, in this order, white is the first amongst the simple colours, and yellow the second, green the third of them, blue is the fourth, as red is the fifth, and black is the sixth (see Kemp, 1990).

Leonardo later doubted the primacy of blue and green. However, by the middle of the 17th century, artistic practice had settled on three primary colours and three secondary colours. The primary colours were red, blue and yellow. The secondary colours could be created as

mixtures of these primaries: green (blue with yellow), orange (red with yellow) and violet (red with blue). The influential 19th-century colour theory of Michel-Eugene Chevreul adopted the same three primary colours. Chevreul was a distinguished French chemist who had been appointed in 1824 to the position of the Director of Dyeing at the Gobelins Manufactory by Louis XVIII. This historic tapestry factory in Paris was established in the 15th century and still operates today. Chevreul had a deep professional interest in pigment colours for use in tapestries. In addition to the three 'simple' or 'primary' colours – red, blue and yellow – he identified the standard three secondaries resulting from their 'binary compounds' – green, orange and violet.

The artist Eugene Delacroix depicted the relationship between the primary and secondary colours using a triangle, with primary colours at the apexes and secondary colours along the sides (see Figure 5.1a). Figure 5.1b shows the more conventional artist's colour wheel composed of the primaries, secondaries and tertiaries (binary compounds of primaries and secondaries) in successive rings. It is significant psychologically that so many different colours can be created by binary combinations of just three primaries. This is a general characteristic of human colour vision known as 'trichromacy', and is exploited in modern reproduction technology, such as digital TV and phone screens. In these displays, each pixel is actually a triad of three different coloured dots; variation in the relative intensities of

Figure 5.1a Delacroix's colour triangle, inspired by Chevreul.

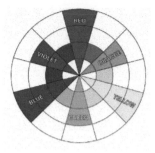

Figure 5.1b A standard artist's colour wheel, based on pigment mixtures.

the three dots produces all the colours available (see the next chapter). Trichromacy derives from the fact that colour processing in the human visual system begins with three different classes of cone photoreceptor in the retina, which react optimally to light in different regions of the visible light spectrum. However, the specific colours forming the primaries in the artist's colour wheel have no relevance to retinal photoreception. Artists' primaries are a consequence of the subtractive natural of pigment mixing rather than a consequence of how colour is analysed by the brain. All pigment mixtures are 'subtractive' in the sense that each added pigment absorbs ('subtracts') a little more of the incident light. A given pigment mix will only reflect the light wavelengths that *all* of its constituent pigments reflect; all other wavelengths are absorbed by one or another pigment in the mixture. As more and more pigments are added to the mix, it tends to appear darker and more grey, due to more wavelengths being taken away from the reflected light (it is impossible to add them back in, of course, by adding a pigment). On the other hand, the light wavelengths that enter the eye mix additively; as more wavelengths are added to a light, it becomes brighter and whiter.

COLOUR CONTRAST

So, the relationships between colours that are depicted in an artist's colour wheel say a great deal more about pigments and dyes than they

do about the psychophysiology of colour. Nevertheless, despite his main interest in pigment dyes, Michel-Eugene Chevreul did achieve a major breakthrough in our understanding of colour perception in 1839, when he published *The Laws of Simultaneous Contrast in Colours*. Weavers at the Gobelins factory complained to him about the colour of some samples of black wool that they had received. Chevreul arranged for the quality of the dyes to be tested, and after the dyes were confirmed to be of the highest quality he realised that the problem was not with the dyes themselves, but with the juxtaposition of the black samples with nearby shades of blue and violet. The problem was a psychological one rather than a chemical one: the nearby colours influenced the *appearance* of the samples. In his book Chevreul duly proposed a law of colour contrast:

> Any given colour would influence its neighbour in the direction of that colour's complementary.

Complementary colours are balanced in the sense that they combine to create a neutral grey or white colour. A surface of a given colour induces the appearance of its complementary colour in a nearby surface that has a neutral grey hue – Chevreul's perceptual law of colour contrast. The artist's colour wheel is arranged so that complementary colours lie directly opposite each other around the circle.

Chevreul's law of colour contrast was very influential in 19th-century art. Claude Monet, an artist who was a master in the depiction of colour appearance, commented:

> Colour makes its impact from contrasts rather than from its inherent qualities . . . the primary colours seem more brilliant when they are in contrast with their complementary colours.

Vincent van Gogh made particularly acute observations about complementary colours. He especially liked using combinations of yellow and blue. In a letter to his brother Theo in 1888 he remarked:

There is no blue without yellow and without orange, and if you put in blue, then you must put in yellow, and orange too, mustn't you?

Van Gogh greatly admired Vermeer's use of this colour pairing. Beautifully balanced blues and yellows can be seen in every one of Vermeer's surviving paintings. Many artists, including Monet and Delacroix, had also noticed that shadows near a bright colour take on the appearance of their complement. So, shadows appear violet when next to yellow drapery or haystacks, and greenish shadows are cast by a red sunset. The complementary colour-tinge seen in shadows is purely perceptual, an instance of Chevreul's law of colour contrast; it is seen even in neutral grey shadows. The existence of coloured shadows illustrates a fundamental psychological property of colour, eloquently stated by the French mathematician Gaspard Monge in 1789 during a lecture to the French Academy of Sciences:

So our judgments of the colours of objects seem not to depend uniquely on the absolute nature of the rays of light that paint the image of them on the retina; our judgments can be altered by the context, and it is likely that we are influenced more by the ratio of particular properties of the light rays rather than by the properties themselves, considered in an absolute manner (see Mollon, 2006).

For example, under a given illuminating light, a surface will appear more red than another if it reflects more light in the longer wavelength region of the spectrum than does the other surface. The *absolute* amount of reflected light in the red region of the spectrum does not matter for redness (or any other colour appearance), only the *relative* amount in comparison with another surface. Absolute light levels at different wavelengths are a poor indicator of the colour of a surface in any case because they can vary with lighting conditions, as mentioned earlier; for example, red and green wavelengths are more predominant in late afternoon and early evening sunlight, whereas blue

wavelengths are more predominant in the morning. So, the visual system recognises the stable colour properties of an object by its propensity to reflect relatively more light at certain wavelengths than other objects, whatever the lighting conditions.

UNIQUE HUES

In contrast to the artists and tapestry makers of the 19th century, with their focus on dyes and pigments, the physiologist Ewald Hering adopted a purely psychological approach to the study of colour. He stated in 1878 that:

> All colours appearing to contain at the same time red and blue, if in very different ratios, can be placed into a series, the first member of which is the purest red and the last the purest blue. This applies in analogous fashion to all blue-green, green-yellow, and yellow-red colours (Hering, 1964).

Graphically this ordered sequence of similar colours forms a circle based on colour similarity. It implies that one cannot transition from, say, a yellow appearance to a blue one without passing through red or green. The ordered sequence of colours that appear quite similar forms a circle. The segments in the inner ring of Figure 5.1c show Hering's ordered hues. The primary, secondary and tertiary colours of the artist's colour wheels are a subset of this hue sequence. Hering identified

Figure 5.1c Hering's perceptual colour wheel.

four particular colours in his hue circle as having a special status in perception, and called them 'primary' or 'unique' hues ('urfarben' in German):

> This description [of a hue circle] makes it clear that there are four outstanding loci in the series of hues . . . primary yellow and primary blue. Likewise, we can name, third, the red and, fourth, the green that are neither bluish nor yellowish primary red and primary green (Hering, 1964).

Hering argued that these hues are unique in the sense that we never experience them as mixtures of any other colours. Furthermore, Hering proposed that the four unique hues form two pairs, blue-yellow and red-green. The basis for this proposal was perceptual: We never experience reddish green or yellowish blue (perceptual mixtures *within* pairs); on the other hand, we do experience colours that are mixtures *across* members of different pairs, namely reddish-yellow (orange), yellowish-green, greenish-blue and blueish-red (violet). The latter four mixtures are shown in the outer ring of the colour wheel in Figure 5.1c in the south-west, north-west, north-east and south-east compass points respectively. The unique hues lie along the cardinal axes (north-south and east-west).

The idea of four unique hues was actually first mentioned by Leonardo sometime between 1482 and 1519 (see the earlier quote). The four hues can be seen in Raphael's painting "Saint Catherine of Alexandria", c. 1507, and also in the 14th-century windows of the Alhambra palaces in Granada, Spain. Hering's theory of two pairs of unique hues is still widely accepted. Many different languages tend to have words that refer to the most typical red, green, yellow and blue hues. These complementary hue pairs recur frequently in the work of many artists including Monet, Delacroix, van Gogh and Raphael to name just a few. Returning to van Gogh, in 1888 he described the colour composition of his painting "The Bedroom" as follows:

> the walls pale lilac, the ground a faded broken red, the chairs and the bed chrome yellow, the pillows and sheet a very pale

green-citron, the counterpane blood red, the washstand orange, the washbasin blue, the window green. By means of all these diverse tones I wanted to express an *absolute restfulness*, you see, and there is no white in it at all except for the little note produced by the mirror with its black frame (in order to get the fourth pair of complementaries into it).

DEPICTING MOVEMENT

A dynamic sense of movement can be evoked in a static artwork in a number of different ways. Some artists skilfully develop a composition in which the arrangement of lines, poses or shapes implies movement. We can see such an effect in many of Titian's compositions in which human figures seem to be suspended in the midst of

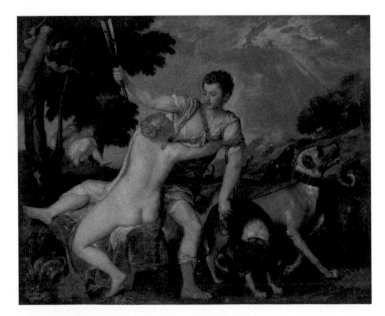

Figure 5.2 Titian, "Venus and Adonis", c. 1555.

Credit line: Digital image courtesy of the Getty's Open Content Program.

a vigorous action such as a leap or step (see Figure 5.2). Other artists apply the paint in such a dynamic way that the paint itself creates a record of its movement, splashing, spinning or dripping across the canvas. Jackson Pollock's action paintings were made using this technique. Scribble drawings also convey in a very direct way the spontaneity and vitality of the mark-making that created them. Op artists such as Bridget Riley do not rely on expressive actions or gestures to suggest movement, but on more subtle, disturbing phenomena that have been described, inaccurately, as optical phenomena (hence the label).

IMPLIED MOTION

Motion is implied in paintings such as Titian's by virtue of the fact that the pose depicted is so unstable that it would be impossible to adopt it for more than moment. Stop-action photographs only became available towards the end of the 19th century, so prior to that time artists had to rely entirely on their perceptual impressions and visual memory when creating realistic depictions of bodies in motion. Artworks featuring horses are particularly fascinating because they were at the centre of a debate in the 19th century about how to depict movement in art. Prior to the 1920s horses were ubiquitous in Western society, as both civilian and military transport, as a source of industrial power (towing barges, horse-drawn carriages and so on) and in entertainment (horse racing, 'hippodrome' displays of equestrian skill and so on). 'Hippology' – the study of the anatomy, physiology and behaviour of horses – was a recognised scientific discipline. Horses therefore figured prominently in a great number of artworks. Galloping horses were traditionally depicted in a pose known as the 'flying gallop' or 'ventre à terre' (belly to the ground); both forelegs are stretched in front of the horse while both hindlegs stretch back to the rear. By the middle of the 19th century, the eminent French painter Louis-Ernest Meissonier had established a reputation as one of the most respected equestrian painters of the era. His depictions of horses in paintings of battle scenes and other historical subject were

praised for their realism. Meissonier had gone to great lengths to study and depict horses accurately, building a small train track in his garden alongside a bridleway, which allowed him travel alongside a walking horse and observe its movements minutely. Meissonier used the flying gallop pose to depict galloping horses, as in Figure 5.3.

However, a series of photographs produced by the English photographer Edward Muybridge in 1878 initiated an impassioned debate about the correct representation of horses in motion. Muybridge had perfected a system for recording a series of photographs of a horse as it galloped past a specially constructed camera shed alongside a racetrack. The shed contained twelve cameras arranged in a row, all trained on the track. Each camera's shutter was connected by means of an electrical contact to a thread stretched across the track at chest height. When a passing horse struck and broke each thread in turn, a contact closed and the corresponding camera shutter was released. The sequences of stop-action photographs that Muybridge recorded gave incontrovertible proof that a galloping horse never adopts a flying gallop pose.

After Meissonier had met Muybridge and studied the photographs he said:

Figure 5.3 Ernest Meissonier, "1807, Friedland", c. 1861.

Credit line: The Metropolitan Museum Public Domain.

All these years my eyes had deceived me. After thirty years of absorbing and concentrated study, I find I have been wrong.

Meissonier repainted the legs of a horse in one of his most famous paintings to match one of the poses in Muybridge's photographs. Other artists, including Frederic Remington and Edgar Degas, followed suit. In Remington's 1896 sculpture "The Wounded Bunkie" (Figure 5.4), the two galloping horses adopt poses that are strikingly different from the flying gallop. They were based directly on Muybridge's photographs.

At about the same time that Muybridge was taking his action photographs in California at around 1880, a French physiologist called Etienne-Jules Marey was setting up a laboratory to study animal movements in Paris. Marey designed a huge camera box equipped with a large, circular rotating shutter, 1.3 metres in diameter. The shutter was perforated with regularly spaced narrow radial slits. As

Figure 5.4 Frederic Remington, "The Wounded Bunkie", 1896.

Credit line: The Metropolitan Museum Public Domain.

the shutter rotated it exposed a single photographic plate with a series of still images each for 1/1000th of a second at a rate of 10 images per second. Marey's technique was therefore more accurate than Muybridge's (which relied on the unpredictable speed of the horse itself to initiate each exposure). Each of his plates contained multiple exposures on the same image, so the trajectory and details of the action could be studied very precisely. Both Muybridge and Marey viewed their photographs as the standard of truth against which artistic depictions of action should be judged. Paul Richer, a Professor at the Ecole Des Beaux-Arts in Paris, declared in 1902:

> Instantaneous photography has opened people's eyes. The revolution has not occurred without resistance, but today it is a fait accompli (see Mayer, 2010).

Photography had, in Richer's view, taught artists "to see nature better and consequently also to interpret it better".

However, many dissented from this view. Ernst Wilhem Ritter von Brucke, a German physiologist and contemporary of Marey's, argued in 1881 that:

> Presumably the artist captures the trotting horse at a certain moment, at the moment that derives from his memory image. The photographic depiction, however, captures it at a random moment, and it must be a special coincidence when this moment coincides with that of the artistic depiction (see Mayer, 2010).

Von Brucke's comments brought a psychological perspective to the problem of depicting horses in motion. A year later, the Victorian psychologist and polymath Francis Galton expressed his explanation for the artistic use of the flying gallop as follows:

> Another cause of confusion lies in the difficulty of watching closely both the fore and the hind halves of the animal

simultaneously. The eye wanders from one to the other and seizes the most characteristic attitudes of each, and combines them into a hybrid monster (Galton, 1882).

The 'certain moment' or 'characteristic attitude' in these two accounts of perceiving a gallop could plausibly be the point of maximum extension of the fore and hind legs, because at this instant the legs reverse so are momentarily stationary and therefore more salient to the viewer.

Artists including Theodore Gericault and Auguste Rodin defended the use of the flying gallop because it is psychologically true rather than photographically true. Horses *look* like they gallop in that way. Gericault and Rodin advocated the continued use the traditional ways to depict action. Rodin stated:

> Yet I believe that Gericault rather than the photograph is correct because his horses have the appearance of running. This comes about because the spectator looks from back to front. . . . It is the artist who tells the truth and photography that lies. For reality, time does not stand still. And if the artist succeeds in producing the impression of a gesture that is executed in several instants, his work is certainly much less conventional that the scientific image where time is abruptly suspended.

The late 18th-century debate about depicting horses in motion is a microcosm of the broader debate in art, mentioned earlier, that was prompted by the introduction of photography. The motivation of many artists subtly changed from the creation of optically accurate and realistic records of the visual world (as in perspective projections), to the depiction of psychologically accurate records of their *impressions* of the world. In the case of movement, this meant depicting a sensory impression of a galloping horse rather than a photographically accurate record. However, standards of realism are

now dominated by photography to such an extent that 'psychological' images like the flying gallop are used very little except perhaps in children's books and films that do not aim for photographic accuracy.

Moving forward into the early 20th-century Modern era, the Futurists made dynamic sensations of movement the leitmotif of their art. The art movement's technical manifesto from 1910 stated:

> Indeed all things move, all things run, all things are rapidly changing. A profile is never motionless before our eyes, but it constantly appears and disappears. On account of the persistency of an image upon the retina, moving objects constantly multiply themselves; their form changes like rapid vibrations, in their mad career. Thus a running horse has not four legs, but twenty, and their movements are triangular.

Umberto Boccioni was a central figure in Futurism. He stated in 1912:

> In order to make the spectator live in the centre of the picture, as we express it in our manifesto, the picture must be the synthesis of what one remembers and of what one sees. . . . We have declared in our manifesto that what must be rendered is the dynamic sensation, that is to say, the particular rhythm of each object, its inclination, its movement, or, to put it more exactly, its interior force.

Some Futurist paintings (as well as Marcel Duchamp's 1912 "Nude Descending a Staircase") were undoubtedly inspired by Marey's multiple-exposure images of bodies in motion. However, the earlier quote from the Futurist manifesto repeats a common fallacy about perceiving motion in visual art: 'persistency of vision'. The same mistaken account is often given as an explanation for the effectiveness of

movies. The story goes that even the briefest flash of light that strikes the retina persists in our visual experience long after it has physically disappeared. So, in a movie film, successive frames (brief snapshots) of an action become stitched together psychologically into a seamlessly smooth movement. As stated in the manifesto, the Futurists tried to depict a Marey-style sequence of these snapshots in a single artwork. So a horse "has not four legs but twenty".

Persistence of vision is a well-known phenomenon that can be traced to the relatively sluggish responses of neurons to rapid visual events. This sluggishness can be seen even in the time-course of the responses of retinal photoreceptors. After a very brief flash of light, photoreceptor response builds to a peak over a period of about one-fifth of a second, and then declines back to its resting level over a slightly longer period. A time period of less than half a second may seem very brief, but it is long enough to cause perceptible effects. The bright streaks created by fast-moving firework fragments are highly visible manifestations of persistence (which actually extends over a longer period of time in dark-adapted eyes). The problem with persistence as a rationale for movies, or Futurist paintings, is that its effect is to blend or blur out successive instants in time so that successive positions become indistinguishable, hence the streaks seen in fireworks. So persistence in a movie would create smears wherever there is movement, not separable, sequentially visible instants of action. Movement perception relies on fast-responding neural circuits in the visual system, known as motion sensors. These circuits are able register the rapid changes in spatial position caused by movement, despite the problem of visible persistence, and encode their direction and speed.

PERCEIVING STATIC IMAGES TO MOVE

The term 'Op Art' is an abbreviation of 'Optical Art', and is used to describe static artworks that evoke surprising sensations of visual movement, vibration or three-dimensional depth. All of these effects

are, of course, psychological and neurological rather than 'optical', but the term Op Art became established after it was used in a *Time* magazine report of an exhibition at New York's Museum of Modern Art called "The Responsive Eye" in 1965. The exhibition catalogue acknowledged the limitations of applying the term 'optical' to the works on display:

> The work of some of the artists represented in this exhibition has been labelled 'optical' or 'retinal'. . . . On the basis of expanded knowledge, our idea of the 'eye' must be more embracing. We know how hard it is to distinguish between seeing, thinking, feeling, and remembering. . . . The 'eye' referred to in our title cannot therefore be assumed to be identical with the anatomical orb or an inert optical instrument.

Indeed one of the artists exhibited, Josef Albers, objected to the terms 'optical' and 'retinal' because the effects created by the art "are psychological and thus happen behind our retina". The exhibition contained works from over 15 countries. The motifs in the paintings were geometric (lines, curves, rectangles, circles) defined by flat colour or monochrome tones, often in very high contrast. Almost all the works were executed in the early 1960s. Bridget Riley's abstract paintings featured prominently in the exhibition. Figure 5.5 shows a monochrome computer-generated image containing a repeating pattern of fine, high-contrast lines in the style of the Op Art shown in the exhibition, such as Riley's paintings. The image arouses disturbing sensations of dazzle and shimmer, that compel the viewer to look away after a few seconds. The catalogue essay for the exhibition characterised the artworks on display as 'Perceptual Abstraction' (a term that Riley herself preferred), which "exists primarily for its impact on perception rather than for conceptual examination". One could describe the scientific history of visual illusions in the exactly the same terms.

Intriguingly, scientific research on perception in the late 1950s and early 1960s had begun to use abstract patterns that were very similar indeed to those depicted in Perceptual Abstractionism. Figure 5.6

Figure 5.5 A computer-generated Op Art style image.

reproduces a figure from a 1957 *Nature* paper by the physicist and neuroscientist Donald Mackay, who was at Kings College London at the time. The radiating grating pattern produces disturbing movement and shimmer effects similar to those seen in many Perceptual Abstractionist artworks, and in Figure 5.5. Mackay had first noticed these effects in 1955 in the repetitive slotted wall-boards used in BBC sound studios to deaden echoes. A great many experiments have been conducted from the 1960s onwards using fine grating patterns consisting of alternating light and dark stripes, just as in Riley's work. The use of these repetitive patterns is motivated not by their appearance but by a mathematic theory (Fourier Analysis). This states that literally all images can be considered as the superimposition of very many grating patterns at different scales,

Figure 5.6 Donald Mackay's ray figure, which appears jazzy and shimmery.

Credit line: Dr. D.M. Mackay, Moving Visual Images Produced by Regular Stationary Patterns, Springer Nature.

orientations and relative positions. The rationale for using gratings in research is that if one understands how the brain responds to grating patterns, one can extrapolate that understanding to all images since they are the summation of many gratings. Contemporary researchers recognise the severe limitations of this kind of extrapolation, but grating patterns are still employed in some areas of perceptual research.

The press release for "The Responsive Eye" exhibition stated that the art exhibited:

> utilises visual demonstrations of experimental psychology and optics (among them the dynamic effects of ambiguous

perspective and moire patterns); it transfers experiments begun in design schools and laboratories to the fine arts; it offers a rich source of study to scientists in several fields.

This statement is borne out by the career of the Hungarian artist Victor Vasarely, who is considered the 'grandfather' of Op Art. Vasarely studied medicine for two years before suspending his studies in 1927 and enrolling in a conventional art school. His artistic practice was influenced by Bauhaus design principles as well as by his continued interest in science. However, beyond Vasarely there is little documented evidence for any cross-fertilisation of ideas and motifs between artists and scientists during the early 1960s. Bridget Riley has distanced herself from scientific approaches to perception, commenting in 1965:

> I have never studied 'optics' and my use of mathematics is rudimentary and confined to such things as equalising, halving, quartering and simple progressions. My work has developed on the basis of empirical analyses and syntheses.

Although her creative process sounds very close to a scientific one, Riley also said:

> It also surprises me that some people see my work as a celebration of the marriage of art and science. I have never made any use of scientific theory or scientific data, though I am aware that the contemporary psyche can manifest startling parallels on the frontier between the arts and sciences.

So evidence for interactions or collaborations between Perceptual Abstractionist artists and perceptual scientists in the early 1960s is lacking, but it is possible that the two groups nevertheless drew inspiration from each other, or were jointly influenced by the dazzling advances in society and technology that were taking place at the time, as well as by the political uncertainties introduced by nuclear

weapons and the Cold War. People at the time were no longer passive spectators of events but more active and engaged with the world. The first demonstration by CND (Campaign for Nuclear Disarmament) took place in the UK in 1958, and the first telecommunications satellite (Telstar) was launched in 1962. The instability of Perceptual Abstractionism chimed with this broader cultural trend towards more active engagement and questioning of accepted truths (the seeds of 1960s counterculture).

In contemporary research, psychologists still draw inspiration from Perceptual Abstractionist artworks. Some researchers have even employed patterns that re-create Riley's motifs ('riloids'). Eye movements figure prominently in the research. While we are viewing the patterns (or indeed any other images), we frequently shift our gaze to different locations. Perceptual Abstractionist art tends to contain very fine, repetitive, often curving, high-contrast patterns that generate strong complementary neural after-images (to see one such after-image, stare at the centre of Figure 5.6 for a few seconds before transferring your gaze to a uniform field such as a blank sheet of paper). As our eyes scan the pattern, coming to rest or fixating at a particular location for a few seconds at a time, the after-image generated by the previous fixation may combine with the pattern seen at the current fixation to create visible disturbances. This is the explanation that Mackay favoured for his shimmer effect (Figure 5.6).

In addition to large voluntary movements, our eyes also engage in tiny, random movements even while we are trying to keep them stationary. These eye movements are usually so small compared to the spatial scale of detail in natural scenes that they do not cause a noticeable disturbance, but the fine, high-contrast detail in some Perceptual Abstractionist art may cause the tiny eye movements to generate signals in neural motion detectors, and so intrude on our consciousness as visible disturbances. There is, however, no single agreed scientific explanation for all the visual effects seen in Perceptual Abstractionism, probably because artists have found many different ways to create the effects, and these different images tap into a variety of neural mechanisms.

CONCLUSION

The common thread running through this and the previous chapter's discussion of space, form, colour and movement is how often artists depart from realistic or 'accurate' depiction in ways that shed some light in the underlying psychological processes. Indeed, artistic decisions to depart from realism as a response to photography define the beginning of the Modern era in the late 1800s. As we have seen, artworks frequently contain subtle or not-so-subtle departures from geometrically accurate perspective and shape, towards distorted space, exaggerated colour contrasts and unnatural poses. These departures have often converged on the same insights as those reached by psychologists seeking to understand how the brain represents the visual world. Both artists and scientists have discovered that the visual system's goal is not simply to represent the visual world as accurately as possible, but to represent the most important aspects of it for our survival.

6

WHAT MAKES GREAT ART?

INTRODUCTION

As discussed in the previous chapters, at the start of the last century visual artists turned away from attempts to achieve physical realism in their work and began searching for some kind of psychological realism instead. This move took art away from the traditional standards of visual beauty that had held sway for centuries. Marcel Duchamp's urinal (Figure 1.2) was so influential because it was the first artwork to reject visual pleasure completely, and assert that the idea or concept was all that mattered for great art. Duchamp reflected in 1942:

> I was interested in ideas – not merely in visual products. . . . It was true I was endeavouring to establish myself as far as possible from 'pleasing' and 'attractive' physical paintings.

This shift in the criteria of greatness is so profound that it is necessary to divide the discussion of the psychology of great art into two sections. The first is devoted to art created prior to the advent of Modern art, and the second is devoted to art in the Modern and Post-Modern era.

TRADITIONAL CONCEPTS OF GREAT ART

Natural beauty was the hallmark of great art for centuries. According to Giorgi Vasari in 1568 the goal of art was simply "the imitation of

the most beautiful things in nature". Over 300 years later the Victorian art critic John Ruskin also saw the primary purpose of art as communicating an understanding of nature:

> Go to Nature in all singleness of heart . . . rejecting nothing, selecting nothing and scorning nothing; believing all things to be right and good, and rejoicing always in the truth.

So in this traditional view, art is a conduit for conveying natural beauty. The obvious question is then: Why are natural things beautiful? Philosophers have had fundamental disagreements on the answer to this question. Some philosophers, including Plato and Aristotle, believed that beauty is an inherent property of an object, just like its size or weight. Certain *objective* characteristics of a shape or body, such as balance and proportion, denote its beauty. According to Aristotle in 350 B.C.E.:

> The chief forms of beauty are order and symmetry and definiteness.

Since the time of ancient Greece, for example, certain body proportions have been considered ideal. The Roman architect Marcus Vitruvius Pollio discussed the ideal proportions of both buildings and human bodies in his multi-volume book *On Architecture*. His ideal human proportions, based on Greek statues, were famously depicted by Leonardo in his drawing "Vitruvian Man".

The opposing *subjectivist* view to the objectivist account of beauty was held by philosophers such as Hume. They argued that 'beauty is in the eye of the beholder', a socio-cultural construction. Hume wrote in 1757:

> Beauty is no quality in things themselves: It exists merely in the mind which contemplates them; and each mind perceives a different beauty.

Subjectivist philosophers viewed 'taste' as a refined ability to perceive quality in an artwork, which could be acquired through education and experience (hence the Grand Tours mentioned in Chapter 2). The art historian Ernst Gombrich used the term 'beholder's share' to refer to the role of the viewer's mind and brain in their experience of art.

Although objectivist and subjectivist theories of beauty each capture some important characteristics of beauty, a comprehensive account of beauty must include roles for both the object and the subject. There seems to be something about the objective properties of a face, for instance, that defines its beauty. Ratings of female facial beauty tend to be consistent across cultures. Psychologists have identified three specific facial features or configurations in both men and women that are associated with beauty: Sexual dimorphism (such as the sizes of the jaw, eyes and lips), symmetry and averageness in the arrangement of features. Darwinian sexual selection can explain why these particular objective features are subjectively appealing to perceivers: They signal the genetic quality and physical health of a potential mate. So beauty arises from an interaction between the physical features of the object being judged and the predisposition of the subject to value certain features more than others.

Picturesque landscape paintings provide another interesting example of how beauty judgements emerge from the interaction between objective properties and viewer preferences that are rooted in our evolutionary past. Landscape is one of the most popular genres in Western art. Certain physical features in landscape paintings seem to be universally liked by spectators, and can be found in the work of the greatest landscape painters such as Claude Lorrain, Nicolas Poussin and John Constable (see Figure 6.1). Their work tends to depict a predominantly rural and open view into the distance, with a scattering of trees and vegetation, rather than one enclosed by dense forest or overhanging rocks. Water features such as a river or lake are often included, as well as human and animal figures, and perhaps a distant building such as the ruin of an ancient castle. The 18th-century

Figure 6.1 Nicolas Poussin, "Landscape with a Calm", c. 1650.
Credit line: Digital image courtesy of the Getty's Open Content Program.

landscape architect Lancelot "Capability" Brown created gardens for grand houses that were inspired by landscape art, containing undulating open spaces broken up by clumps and belts of trees, incorporating water features such as lakes and streams. What makes landscape art so attractive and picturesque? As in the case of facial beauty, several possible ultimate explanations are rooted in evolution. One hypothesis argues that we prefer certain landscape features because they form part of the ancestral savannah landscape in which humans first evolved. However, there is relatively little sound evidence to support the hypothesis. Furthermore, humans evolved in environments that underwent continual change, either due to natural events (climate change, earthquakes, volcanoes) or migration. So a retained preference for one ancient habitat seems implausible. Nevertheless, some aspects of landscape preferences in art may relate to ancient habitat selection. Curiosity about landscape may be a vestige of the adaptive urge to explore our local environment in search of food, shelter and

mates, and is found in many animals. The pleasure engendered by features denoting 'mystery' in landscape art (such as a path disappearing into the distance) may relate to innate curiosity which, as noted in Chapter 2, is rewarding in itself. We also may be predisposed to search for places that offer a good view and a safe refuge, and find it rewarding to find such places in a landscape. Other humans, animals and water are also so important for survival that we are predisposed to seek them out in a landscape.

These two examples of natural beauty, one based on human faces and the other on natural landscapes, emphasise how traditional judgements of beauty in art depended at least in part on the extent to which artists were successful in capturing the psychological essence of real-world subjects that we find inherently interesting and attractive. Seventeenth-century Northern European still life paintings create such captivating and convincing *trompe l'oeil* depictions of everyday objects that the viewer is tempted to reach out and pick them up. The power of Rembrandt's or Holbein the Younger's portraits rests on their ability to capture the subtle play of emotion, mood and temperament on the face of the sitter. Direct gaze is also instinctively powerful, whether from a real person or a painted portrait. Other figurative paintings that are widely regarded as among the greatest in the Western tradition engage with the viewer at an intellectual level as well, initiating a mental search for the meaning of the work. Paintings such as van Eyck's "Arnolfini Portrait" (1434), Velasquez's "Las meninas" (1656) or Manet's "Dejeuner sur l'herbe" (1862) are famous for the debates that they have inspired about the rationale for the artist's choice of the particular people and objects that were included in the painting.

By the start of the 20th century artists began to question traditional notions of aesthetic merit. In 1927 one of the instigators of abstract art, Kasimir Malevich, declared:

> When, in the year 1913, in my desperate attempt to free art from the ballast of objectivity, I took refuge in the square form and exhibited a picture which consisted of nothing more than a black square on a white field, the critics and, along with them,

the public sighed, "Everything which we love is lost. We are in a desert. . . . Before us is nothing but a black square on a white background!" . . . But this desert is filled with the spirit of non-objective sensation which pervades everything. . . . This was no 'empty square' which I had exhibited but rather the feeling of non-objectivity.

The public is still convinced today that art is bound to perish if it gives up the imitation of 'dearly loved reality' and so it observes with dismay how the hated element of pure feeling – abstraction – makes more and more headway.

The time was ripe for new definitions of 'good' art to emerge, that tapped into a different aspect of human psychology.

MODERN CONCEPTS OF GOOD ART

As outlined in the previous chapter, by the late 1800s artists had begun to explore ways to abandon realistic depictions of visual beauty in favour of a purer, more abstract and fundamental concept of beauty that was rooted in the way we perceive the world, but at the same time detached from it. The French writer Appollinaire said in 1912:

While the goal of painting is today, as always, the pleasure of the eye, the art-lover is henceforth asked to expect delights other than those which looking at natural objects can easily provide.

According to Picasso, writing in 1935:

Art is not the application of a canon of beauty but what the instinct and the brain can conceive beyond any canon. When we love a woman we don't start measuring her limbs.

The shift away from traditional standards of aesthetic beauty in the late 19th century has made judgements of what makes great art much more difficult. The abandonment of traditional, life-like appearance

in art, which taps into evolved human preferences for certain real-world forms, has clouded judgements of artist quality. The art establishment initially resisted the move. In 1890 Cezanne was considered to be a clumsy artist, whereas Bougereau's work was viewed as impeccable. Nowadays Cezanne is regarded and one of the timeless giants of Western art, while Bougereau is little more than a footnote in 18th-century French art. Gustav Klimt and Egon Schiele were once far less well regarded in Vienna than other artists such as Hans Makart, but now the tables are turned.

The art critic Clive Bell argued in 1914 that aesthetic emotion is aroused by "significant form" in certain artworks:

> In each, lines and colours combined in a particular way, certain forms and relations of forms, stir our aesthetic emotions. These relations and combinations of lines and colours, these aesthetically moving forms, I call 'Significant Form', which is "the one quality common to all works of art" . . . it need be agreed only that forms arranged and combined according to certain unknown and mysterious laws do move us in a particular way, and that it is the business of an artist so to combine and arrange them that they shall move us (see Zeki, 2013).

Bell's concept of significant form in an artwork is independent of recognisable reality. It has fuelled some debates about beauty in art, most recently regarding the parts of the brain that mediate the experience of significant form. However, the definition of significant form is somewhat mysterious and circular. It seems that one does not know what a significant form looks like until one sees it. As Semir Seki (2013) points out, although symmetry and regularity are candidate significant forms, they are not universally prized. For example, the Japanese aesthetic sense favours asymmetry and irregularity, called 'fukinsei'. Some possible sources of significant form were mentioned in the previous chapter. Bell believed that Cezanne's work manifested significant form most purely. So, there may be a connection between his significant forms, Cezanne's more abstract basic forms, and the internal forms

by which shapes are be represented in the brain. Significant form may also relate to global pictorial properties that resonate with visual processing: Scale-invariance and fractality have been proposed as significant statistical qualities in images that make them more attractive; complementary colours generate balanced neural responses.

Some contemporary criteria for whether an artwork is good have dispensed entirely with visual qualities. Contemporary criteria include art-historical significance, popularity (or the lack of it), financial value and 'seriousness'. The art-historical significance of a work may be very important for those who know a lot about art. For example, the significance of the painting "Salvator Mundi" changed completed when it was re-attributed to Leonardo da Vinci himself rather than to one of his studio assistants (though specialists still disagree on the attribution). On the other hand, if you know relatively little about the artist's personal, social and cultural history and context, this criterion is essentially invisible.

Popularity seems to be largely irrelevant as a criterion of goodness as far as the contemporary art establishment is concerned. Indeed, it may count against an artist and their work. L.S. Lowry has long been popular with the public, but his works are rarely hung in galleries. David Hockney's exhibition at the Royal Academy in 2012 was the most popular in the UK, and fifth most-popular in the world at the time, but was largely disliked by the art establishment. Perhaps the problem with popular artists such as Lowry and Hockney as far as the art world is concerned is that art insiders want to expand the public's consciousness of what is thought of as 'good' art, rather than appear to pander to popular taste. There seems to be a Catch-22–style rule governing the relation between the popularity of an artist and their status in the art world (by which I mean other artists, curators, gallery owners, collectors, art historians, publicists, writers and so on): An artist who is highly praised by the art world will rightfully become popular with the public, and so expand the public's awareness of 'good' art. As soon as the artist holds a popular exhibition, they would no longer be praised by the art world (because the work no longer expands awareness), and should therefore become unpopular. This

catch is difficult to avoid. Grayson Perry said, "An artist's job is to make new clichés". Research indicates that popularity may feed on itself. One study investigated whether the degree of exposure to artworks itself influences liking (Cutting, 2003). The study concluded:

> We like the ones we have seen before and, particularly, those we have seen many times.

The effect of 'mere exposure' on liking for something one sees or hears is well known in psychological research. It probably plays an important role in influencing consumer choice during advertising campaigns.

Among the most expensive artworks sold in recent years is a 16th-century Renaissance work attributed to Leonardo ("Salvator Mundi", around US $450 million), 19th-century Post-Impressionist works by Paul Gauguin ("Nafea Faa Ipoipo", US $210 million) and Paul Cezanne ("The Card Players", US $250 million) and 20th-century abstract paintings by Jackson Pollock ("Number 17A", around US $200 million) and Willem de Kooning ("Interchange", US $300 million). Art is undeniably now an asset class. It is currently considered as one of the two greatest stores of wealth internationally today (the other top asset class being property). Artworks are so popular as investments because they are marketable internationally, are relatively safe from fluctuations in a particular country's economy or currency and can be 'securitised' to generate income without having to be sold. So, what determines monetary value? The auction price reflects the investment value of a work of art rather than its purely artistic value. There are many factors at work, some of which seem surprisingly simple. In general, large paintings usually cost more than small paintings, but value is largely dependent on the artwork being validated by the community of artists, dealers, collectors, curators and critics. Attention from an influential figure such as John Ruskin or Charles Saatchi can have a major impact on monetary values. Are the paintings listed at the start of the paragraph really the best paintings in the history of art? Is Paul Cezanne's "The Card Players" four times

as good as Vincent van Gogh's "L'Allee des Alyscamps" (a mere US $66 million)? Monetary value is not what makes an artwork important, of course, but monetary value *does* matter if art is treated as an asset class.

Post-Modern performance art was arguably a reaction against the commodification of the 20th-century art, in which artists' studios became production lines. By the 1980s art had, according to some critics, become complacent and surrendered to mass media and consumption. By its very nature, performance art subverted this business model. It leaves no lasting artefact that can be bought and sold on the market. The Post-Modern art movement self-consciously stepped off the conveyor belt of progress through successive movements, each reacting to its predecessor. There were no longer any boundaries defining what was and was not art, or what was good art and what was bad art. Post-Modern artworks often make ironic or even mocking reference to the standards and style that defined previous movements. So contemporary artists tread a fine line, being cynical and ironic without dispensing with seriousness, sincerity and authenticity (as well as marketability). As the video artist Nam June Paik is reputed to have said:

> An artist should always bite the hand that feeds him – but not too hard.

In order to stay on the right side of the line, and signal their serious intent, some Post-Modern artists address huge, global issues in their work. Other artists remain fairly inscrutable about their intent, leaving viewers and buyers to form their own judgements. Conceptualism is pre-eminent in contemporary art. It began in the 1960s, initially promoted by the artist Sol LeWitt, who declared that:

> In conceptual art the idea or concept is the most important aspect of the work. When an artist uses a conceptual form of art, it means that all of the planning and decisions are made beforehand and the execution is a perfunctory affair.

In 1953 Robert Rauschenberg bought a painting by Willem de Kooning and then erased it. The concept was to challenge the viewer to consider whether erasing the work of a fellow artist is a creative act, and whether the act is 'art' only because a famous artist had done it.

Where art once strived for beauty, it now strives for conceptual 'seriousness'. The artists, curators, gallery owners, writers and so on who make up the modern art world often try to bestow seriousness on an artwork by means of the text in artists' statements, exhibition guides, wall texts and press releases. The peculiar form of English to be found in these text forms was called 'International Art English', or IAE, in a controversial and satirical essay by David Levine (who is an artist) and Alix Rule (a sociologist). IAE is, they argued, characterised by complex, apparently endless sentences containing many dependent clauses. Almost all verbs are accompanied by adverbs, such as in 'radically questions' and 'subversively invert'. According to Rule and Levine:

> IAE has a distinctive lexicon: *aporia, radically, space, proposition, biopolitical, tension, transversal, autonomy*. An artist's work inevitably *interrogates, questions, encodes, transforms, subverts, imbricates, displaces*.

IAE apparently has its roots in translated French Post-Structuralist writing of the 1970s, perhaps explaining why it "sounds like inexpertly translated French". Whatever its origins, the complexity and vagueness of IAE helps to shroud contemporary art in mystery and ambiguity, muddying the waters around the meaning and value of a work. The key to understanding the different psychological processes that mediate judgements of quality in traditional and Modern art lies in the distinction between the sensory and decision factors that bear on perceptual judgements.

SENSORY AND DECISION COMPONENTS IN PERCEPTUAL JUDGEMENT

Psychologists distinguish between two components that form part of all sensory and perceptual judgements (see the flow diagram in

Figure 6.2). One component is driven by sensory processes, and is the route by which sensory qualities such as colour, size, depth and motion influence judgements. The other component involves the cognitive processes by which knowledge, memory, context and expectations exert an influence on perception. These decision factors were mentioned in Chapter 1 (remember the Hawthorne effect and Grayson Perry's art goggles). The flow diagram shows a simple example of the interaction between sensory and cognitive processing. In the absence of any other information, the image may appear to be a large irregular black splodge on a white background. Once you know that the image depicts a frontal view of a woman's face lit from the right-hand side, this contextual knowledge may help a new interpretation of the sensory data (the splodge) to emerge. A further piece of information may induce another interpretation: The splodge also looks like a right-side profile view of a man playing a saxophone.

The interplay between sensory and decision factors is not limited to a specific class of ambiguous or impoverished images but is a universal feature of perception. Despite the huge amount of visual information that continually enters the eye, images inherently contain many ambiguities. The lower part of Figure 6.2 shows a very simple

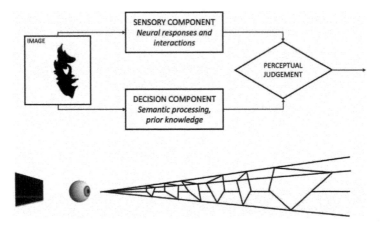

Figure 6.2 Top: Sensory and decision components in perceptual judgements. Bottom: Even images of simple shapes are ambiguous.

example of the problem. What real-world shape created the silhouette image on the left? Very many different flat shapes (just a few examples are shown) all create the same projected silhouette at the eye. The human brain automatically resolves this kind of ambiguity in the sensory data by making use of experience, knowledge and expectations. In the particular case of the silhouette in Figure 6.2, we apply an assumption based on our experience of the built environment that symmetrical rectangular shapes are much more common than asymmetrical ones, and unconsciously reject all but one interpretation.

So seeing always involves a flexible, hugely complex but consciously unknowable interaction between the incoming visual information, our experience, and the expectations set up by context. Traditional criteria for good art rely heavily both on sensory data from the neural sub-systems that evolved to automatically process images of natural scenes, and cognitive data based on the recognition of real-world forms and their context. Modern criteria for good art rely more heavily on the decision factors that influence judgements by means of the knowledge-based, conceptual content of art. IAE could be seen as one way to supply this content.

AUTHENTIC VERSUS FAKE ART

Fakery is a significant problem in art. Many artworks have been passed off convincingly as the work of great artists even though they were produced by expert fakers who copied the style of the artist. There may be many more fakes on display and in circulation than the art world is willing to admit. For example, an expert on the work of the 17th-century artist Frans Hals estimated that only around 70% of the paintings attributed to him were authentic (see Bellingham, 2012). The most infamous faker of the 20th century, Han van Meegeren, produced a fake painting by Hals that was validated and bought by a Hals connoisseur as the genuine article. Van Meegeren also created a number of fake paintings by Johannes Vermeer. The world's foremost experts on Vermeer had declared his fakes as genuine, and rejected van Meegeren's claims to have painted them until incontrovertible

proof was provided (van Meegeren only confessed because he was accused of the treasonous offence of selling Vermeer's work to the Nazis during World War II; selling a fake was a different matter altogether). The faker John Myatt released over 200 fakes onto the art market before he was caught. Only 80% of his fakes have been recovered, so about 40 of his paintings are still masquerading as the real thing in galleries around the world (he won't disclose where they are). After serving four months of a 12-month sentence, Myatt went into business legally creating what he calls 'genuine fakes', signed with his own name (with a hidden computer chip to prevent anyone passing the work off as the product of another artist).

Fakers such as John Myatt, Han van Meegeren, Ken Perenyi and Wolfgang Beltracchi have an undeniably extraordinary ability to paint in the style of many of the world's greatest artists, making the task of detecting the fakery incredibly difficult. It can be difficult to establish the credentials even of original works of art. Historically, artists have often neglected to sign their work, or to keep records of what they painted and to whom they gave or sold their works. Furthermore, from the time of the Renaissance the work of successful artists has involved significant contributions from assistants and apprentices in their studios. So the provenance of a newly discovered painting may be obscure, and reliance then falls on contemporary experts or connoisseurs on whom the art world has conferred the authority to adjudicate on whether a given work should be accepted as authentic. Art historians and critics have long argued that connoisseurship is the safest way to establish an artwork's authenticity. Connoisseurship can be defined as:

> The received tradition that a practiced expert observer can tell an original from a fake or forgery by using a combination of visual memory and optical astuteness in order to identify the unique 'hand' of the artist (Bellingham, 2012).

The practice of connoisseurship became established in the 19th century. In 1880 the Italian art critic Giovanni Morelli argued that artistic attributions should:

not only be aesthetic and subjective ones, depending on individual taste and humour; they must be based on tangible facts perceptible to every observing eye.

Modern forensic analysis is now used to check the physical characteristics of a painting (chemical properties of the paint, X-ray, infrared imaging and so on) but this evidence is not always conclusive. When creating fake paintings by Johannes Vermeer, the artist Han van Meegeren took great care to re-use canvases dating from the time when Vermeer was at work, painted with exactly the same pigment mixes as Vermeer, and he even built a special oven to 'cook in' a convincing impression of the fine network of surface cracks (craquelure) that develop in 300-year-old paintings.

Ultimately, the decision about whether to accept a work may be forced to rely on a connoisseur's judgement: Does the work look like a painting by the artist under consideration? The last sentence of Giovanni Morelli's argument above is particularly problematic from a psychological perspective, because perceptions can never be regarded as 'facts'. As discussed in the previous section, perceptual judgements always involve a combination of sensory data and cognitive or decision factors. A connoisseur's judgement may be unconsciously influenced by their desire to be the person who unveiled a rare, newly discovered masterpiece by Frans Hals, Johannes Vermeer or Leonardo da Vinci. Indeed, cognitive processes are particularly active during a judgement about authenticity. Recent neuroimaging research (Huang et al., 2011) indicates that judgements of authenticity activate brain areas that are known to be involved in other tasks that require the evaluation of multiple goals and hypotheses. The scale of the fakery problem in art demonstrates the power of cognitive biases in judgements of authenticity.

Questions about the authenticity of artworks are not confined to fakery. Connoisseurship is also brought into play when deciding on the correct attribution of artworks that were not intended to deceive spectators. For example, there is a painting in Apsley House, UK, called "Danae Being Seduced by Jupiter". The painting has been attributed to the Venetian master Titian. But in 2019 an expert on Titian, Professor Charles Hope, challenged this attribution, arguing that the

painting is a copy by a 'minor hand'. He argued that the paintwork is "inferior" and that a "a much more beautiful" version in the Prado, Madrid, is the original painted by Titian. Another expert, Professor Paul Joannides, disagreed with Hope and maintained that the Prado Danae is not Titian's work, but the Apsley House Danae is genuine. In cases such as this, there is no way to decide between the ultimately subjective opinions of the connoisseurs, giving different weight to the various cognitive factors at work in the decision.

Once a work of art is identified as not the genuine article, either a fake or a follower's copy of an original, its cultural and monetary value plummets. Are fake artworks really worthless? In monetary terms, the answer is probably yes, for the reasons given earlier about art as an asset class. However, according to Clive Bell (the proponent of 'significant form') writing in 1914, fakery should not matter:

> If the forms of a work are significant its provenance is irrelevant.

Bell argued that an artwork should retain an authentic aesthetic integrity regardless of its provenance. On the other hand, and as we saw in the first chapter, a powerful psychological characteristic of art is its capacity to express emotion. Once an artwork is identified as a fake, any emotion conveyed in it is likely to be viewed as false, because the faker's aim is to fool the spectator rather than to authentically express an emotion.

ORIGINALS VERSUS REPRODUCTIONS OF ART

Prior to the development of colour reproduction technologies in the 20th century, the only way that one could view an artwork, at least in a visual form that approximated the original (e.g. not an etched reproduction), was to view the actual work in the artist's studio or a gallery. The availability of reproductions is now so ubiquitous than one can view almost any famous artwork simply by conducting an image search on your favoured digital device. You merely need to click your finger rather than travel to a gallery and seek out the artwork on

its walls. How much difference can it make to rely entirely on viewing colour reproductions of artworks rather than the originals? The philosopher Walter Benjamin argued in 1936 that the missing quality in reproductions is the 'aura' of an artwork:

> Even the most perfect reproduction of a work of art is lacking in one element: Its presence in time and space, its unique existence at the place where it happens to be.

Aura or 'presence' described in this way seems rather mysterious. Some of that mystery may derive from the cultural memories evoked by an original artwork; its 'hauntological' dimension (touched by the ghosts of past art). Scientific studies have shed light on some of the sensory characteristics that contribute to an original artwork's aura and presence. Studies have found that, although some simple formal qualities are judged in the same way in reproductions as in the originals (such as symmetry and complexity), evaluative judgements of 'surprising', 'interesting' and 'pleasant' are more positive in the original than in the reproduction. Furthermore, artworks are liked more and rated as more interesting when viewed in a gallery rather than in a laboratory, regardless of whether they are originals or reproductions. The combined effects of both sensory factors and contextual factors on viewers' experience of artworks in galleries echo the previous discussions of how these two sets of factors exert an influence on all perception, not just on art perception. What psychological factors might contribute to the enhanced experiences associated with viewing original artworks as opposed to reproductions?

First, there is the issue of the actual or absolute size of an artwork. Visual art can vary in size massively, ranging from a miniature portrait barely three centimetres tall, to many metres for a very large painting or an immersive installation (see Figure 6.3). Picasso's "Guernica", for example, measures 3.5 x 7.8 metres; Jackson Pollock's "Mural" is 2.4 x 6 metres; and Rembrandt's "The Night Watch" is 2.3 x 4.4 metres. Size matters to the viewing experience: A modestly sized work of art such as a 17th-century Dutch interior or still-life painting

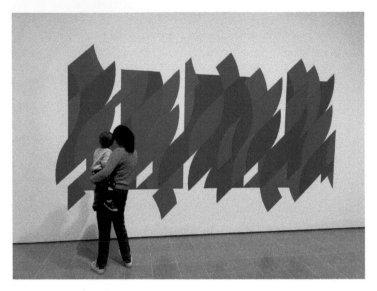

Figure 6.3 The absolute size of an artwork affects the visual impact that it makes on the viewer.

(sometimes less than 50 cm tall) draws in the viewer, inviting them to participate in an intimate experience at close quarters. At the other extreme, monumentally large artworks such as the mural-sized paintings of the American Abstract Expressionists have a grandeur that can overwhelm and surround the viewer.

The artist's aim in creating a large work of art is presumably to impart a sense of awe; the scale of the artwork conveys the artist's ambition for the work, and subconsciously influences the viewer's response to it. These effects of size are obviously lost completely when one views reproductions at reduced scale in a book or on the screen of a small digital device. The art critic Robert Hughes compared the impact of two Picasso paintings: "Three Women", 1908, measuring 200 x 178 cm, and "Still Life with Chair Caning", 1912, measuring 29 x 37 cm, one-fifth of the size, as follows:

> The former is meant to stand up before the eye structurally, like the Michelangelo *Slaves* . . . ; the latter accepts one's gaze more

intimately, like a view through a little window. But when both come out the same apparent size in a plate or a slide, the penumbra of meaning inherent in their actual size as paintings cannot survive (Hughes, 1990).

Actual size was also critically important to sculptor Henry Moore, writing in 1937:

> Yet actual physical size has an emotional meaning. We relate everything to our own size, and our emotional response to size is controlled by the fact that men on average are between five and six feet high. An exact model to one-tenth scale of Stonehenge, where the stones would be less than us, would lose all its impressiveness.

Since Edmund Burke's 18th-century treatise on the sublime, the perceived vastness of an object or scene has been associated with its power to evoke feelings of awe or sublimity in spectators. The absolute size of an object can be estimated from incoming sensory data (angular subtense and estimated distance, as discussed earlier in the book). Size is clearly important in an evolutionary context, since it communicates the potential or otherwise of the object to overwhelm the spectator, whether they are viewing a natural phenomenon such as flowing water and tumbling rocks, or a biological form such as a bear. Artists may consciously or unconsciously try to tap into the raw sensory power of absolute size when they decide on the dimensions of their artwork. Indeed, immersive artworks only succeed if they physically overwhelm the spectator. However, there has been relatively little systematic psychological research on the effect of size on spectators' experiences of artworks. There is some evidence that larger works are judged more positively, and conversely artworks that are rated more highly are perceived as larger.

Apart from sheer size, reproductions of artworks can differ from the originals in a host of other ways. All reproductions are created in two steps. First, the original is photographed or scanned by a

recording device. Second, the recorded image is rendered in print or on a screen. Both the recording and rendering processes introduce changes. Fine textural details and sharp edges may be blunted in the rendered image, due to unavoidable limitations in the ability of the recording or rendering device to convey such details (e.g. optical blur in a recording lens). The reproduction process may even introduce spatial artefacts in the form of visible streaks or moire fringes, caused by fine texture in the original interacting with the limited resolution of the reproduction equipment. In terms of tonal rendition, reproduction technologies enhance mid-tones at the expense of the highest and lowest tonal values, so subtle variations in highlights and lowlights in a painting are unavoidably lost in the reproduction.

Colour rendition is especially prone to loss and distortion. In 1931 the Commission Internationale de l'Eclairage (CIE) developed a standard graphical representation of the hues visible to human observers, known as the CIE chromaticity diagram (see Figure 6.4).

Figure 6.4 CIE chromaticity diagram showing the gamut of visible colours available to painters, and the gamuts available in three reproduction systems.

Pure spectral colours are distributed along the curved perimeter line bordering the colour space of the diagram. Neutral grey lies at the centre of the space. The complete range (gamut) of colours that we can see, and which are available to artists using appropriate pigment mixtures, lie inside the perimeter. The three smaller areas within the CIE colour space of Figure 6.4 represent the gamut of colours available using three different reproduction technologies, due to limitations in the technology; colour film, printing inks and graphics displays. The gamut of colours available in reproductions is clearly significantly smaller than that in original artworks, especially in print form (dashed line). In general, the originals contain colours that are beyond the gamut of colours that is available to the reproduction system. One study of paintings in the National Gallery of London found that up to 68% of the pixels in the photographic reproductions represented colours in the original that were beyond the gamut of the reproduction system:

> Even the seven-colour [printing] process with six primary inks plus black cannot reproduce certain extreme pigment colours such as cadmium yellow or ultramarine, unless special inks are made up from the actual pigments in question (MacDonald & Morovič, 1995).

The out-of-gamut colours must be modified or mapped in the reproduction onto a colour that is within the gamut of the device, but as close as possible to the original colour. The precise colours that are mapped, and the mapping method, vary with different recording and rendering technologies. So the colours present in reproductions of artworks are only ever approximations to the actual colours used in the original artworks.

For all these reasons and more, a reproduction of an artwork may be a pale and impoverished imitation of the original. Judgements of the greatness or otherwise of an artwork should be considered provisional at best until you have had the opportunity to view the original version rather than a reproduction. Apart from the effect of absolute size, the colour, tonal range and detail that one can see in an original

compared to a reproduction often takes the breath away. Very close inspection of an original (within the physical limits set by the gallery) can also reveal intimate details of the artist's physical mark-making and paint-handling that are completely invisible in a reproduction.

ART AND SEXISM

Surveys show that about two-thirds of art gallery visitors are female, and about the same proportion study for degrees in the creative arts and design sectors, so a great many women obviously take a deep interest in visual art. Yet a tiny percentage of the art on display in most galleries is made by female artists. The National Gallery of London's permanent collection of 2,300 works contains only about 10 paintings made by female artists. Just 11% of the 260,000 acquisitions and 14% of exhibitions at 26 prominent American museums over the past decade were the work by female artists, according to an investigation by *artnet News*. Moreover, in the UK in 2018, 88% of auction sales were of art by male artists, with female artists accounting for only 3% of the highest grossing sales.

Under-representation of female artists is a long-standing problem. It was so bad in the 1980s that a group of female artists in New York formed the Guerrilla Girls to draw attention to the problem. They wore gorilla masks and distributed posters displaying messages such as:

> Do women have to be naked to get into the Met. Museum? Less that 5% of the artists in the Modern Art Sections are women, but 85% of the nudes are female.

The problem cannot be due to the lack of great art produced by women. The contemporary art world does now at least acknowledge the many female artists throughout the history of art whose work is at least the equal of many of the great male artists. The list includes (among very many others):

Sofonisba Anguissola (1532–1625)
Artemisia Gentileschi (1593–1656)
Judith Leyster (1609–1660)
Elisabeth Vigee Le Brun (1755–1842)
Georgia O'Keeffe (1887–1986)
Louise Bourgeois (1911–2010)
Lee Krasner (1908–1984)
Rosa Bonheur (1822–1899)
Berthe Morisot (1841–1895)
Mary Cassatt (1844–1926)
Tamara de Lempicka (1898–1980)
Barbara Hepworth (1903–1975)
Frida Kahlo (1907–1954)
Agnes Martin (1912–2004)
Helen Frankenthaler (1928–2011)
Yayoi Kusama (b. 1929)
Bridget Riley (b. 1931)
Maggi Hambling (b. 1945)

Traditional treatments of art history exclude any mention of these female artists. For example, Ernst Gombrich's influential *Story of Art*, now in its 16th edition, mentions no female artists at all. Artemisia Gentileschi is now considered to be one of the most accomplished painters in the history of European art (see Figure 6.5), yet the National Gallery in London only recently made its first acquisition of the 60 or so works by Gentileschi (for the relatively modest price of £3.6 million). Only three other works by Gentileschi are in UK collections. The National Gallery Board of Trustees appointed its first female chair in 2015. The Royal Academy of Arts in London elected its first female president only in 2019. Two of its founding members in 1768 were women, but it was not until the mid-20th century that the Royal Academy elected any more.

Why have female artists been excluded from the art world? The problem is partly a societal and art-historical one. A successful

Figure 6.5 Artemesia Gentileschi, "Esther before Ahasuerus", c. 1630.

Credit line: The Metropolitan Museum Public Domain.

career as an artist generally requires both training and patronage, neither of which have been readily available to women in Western society for centuries, due to traditional divisions in male and female roles. Women were not allowed to enrol in academic art schools until the late 19th century, and were not allowed to draw male nudes, so had to draw subjects such as flowers (now a traditional 'female' subject). Historically, several vicious circles have combined to suppress the contributions of female artists to the history of art. Work by female artists has not been collected by individuals or institutions, researched by historians, or conserved by art dealers (all of whom were predominantly male). In turn, gallery acquisition committees have been reluctant to pay high prices for female artists who lack an auction history that could validate the prices. So, the permanent collections of national galleries, which form the accepted canon of the greatest art in history, have an entrenched bias against female art.

In addition to societal and historical biases, some ingrained psychological biases may also operate to underplay the contributions of female artists. There is no scientific evidence to date that art produced by female artists is inferior to that produced by male artists. Nor, it seems, can the sex of the painter be inferred simply by looking at the art. In a recent online experiment (Adams et al., 2017), non-specialist participants were asked to guess the sex of the artist who produced each of 10 paintings (five were made by male artists and five by female artists). They performed no better than they would have done by tossing a coin. On the other hand, sex as communicated through a name can itself also bias judgements of music, teaching and so on. Such sex-based biases can be added to the other decision biases described earlier that contribute to artistic judgements.

7

CREATIVITY IN ART AND SCIENCE

INTRODUCTION

On the basis of the previous chapters, you may have discerned many commonalities in the ways that artists and psychological scientists think about visual problems, and even in the ways that they work on these problems. I believe that the similarities actually run deep. There are common underlying psychological processes in both activities.

Creativity is a cognitive attribute that is generally much more closely associated with artists than with scientists. Artists are quintessentially described as gifted, inventive, original and productive. By contrast, scientists are considered to be brainy, laborious, methodical and obsessive ('geeky'). In reality, it would be impossible to do great science without being creative. Similarly, the greatest artists all possess a substantial helping of intelligence and obsessiveness. Creativity has to be nurtured and coaxed, both in art school and in science classes. The Finnish photographer Arno Rafael Minkkinen invented a very apt metaphorical story about how to nurture artistic creativity, called the Helsinki Bus Station Theory, that can be paraphrased as follows:

In the bus station some two-dozen platforms are laid out in a square at the heart of the city. At the head of each platform is a sign posting the numbers of the buses that leave from that particular platform. The bus numbers might read as follows: 21, 71,

58, 33, and 19. Each bus takes the same route out of the city for at least a kilometre, stopping at bus stops at intervals along the way.

Now let's say that each bus stop represents one year in the life of an artist, meaning the third bus stop would represent three years of activity.

Ok, so you have been working for a couple of years on studies of nudes. Call it bus #21.

You take the studies to a high-profile gallery and the curator asks if you are familiar with the nudes of Lucien Freud. His bus, 71, was on the same line as yours. Or you go to another gallery who suggest that you check out Jenny Saville, bus 58, and so on.

Shocked, you realize that what you have been doing for two years others have already done. So, you hop off the bus, grab a cab (because life is short) and head straight back to the bus station looking for another platform. This time you are going to develop a Pop Art style for nudes.

You spend two years at it, and produce a series of paintings that elicit the same comment when you present it: haven't you seen the work of Tom Wesselman?

So once again, you get off the bus, grab the cab, race back and find a new platform. This goes on all your creative life, always showing new work, always being compared to others.

What to do?

It's simple. Stay on the bus. Stay on the f****** bus.

Why, because if you do, in time you will begin to see a difference. The buses that move out of Helsinki stay on the same line but only for a while, maybe a kilometre or two. Then they begin to separate, each number heading off to its own unique destination. Bus 33 suddenly goes north, bus 19 southwest.

For a time maybe 21 and 71 dovetail one another but soon they split off as well.

It's the separation that makes all the difference, and once you start to see that difference in your work from the work you so admire (that's why you chose that platform after all), it's time to look for your breakthrough.

Suddenly your work starts to get noticed. Now you are working more in your own way, making more of the difference between your work and what influenced it. Your vision takes off.

A fascinating aspect of this story about artistic creativity for me is that it is equally convincing as a story about how to nurture a scientific 'voice', if one replaces references to art and artists' names with references to experiments and scientists' names. In the same way that art students traditionally copied the work of the Old Masters during their training, during the early stages of scientific training students attempt to replicate famous experiments conducted by renowned scientists in their discipline. Replication involves repeating an experiment using exactly the same methodology, and (hopefully) obtaining results that match the original. Gradually, the student becomes more skilled in the techniques, and in thinking about associated scientific problems and issues, so in time their experiments begin to ask new questions. The fledgling scientist gradually develops a unique 'voice', in the sense of having a characteristic way of thinking about scientific problems and how to address them in their research. Ultimately, each scientist working in a particular field will develop their own unique perspective, perhaps associated with a novel technique or new theory that they have developed.

THE PSYCHOLOGY OF CREATIVITY

According to the cognitive scientist Margaret Boden (2010), "human creativity is something of a mystery, not to say a paradox". It almost defies definition. Boden describes creativity simply as "the generation of novel, surprising, and valuable ideas". Each of those three adjectives are themselves loaded in ambiguity and multiple meanings. What counts as novel, or surprising? So definitions of creativity are inherently subjective. Psychologists have attempted to make some progress in understanding creativity by defining it operationally using tests of divergent thinking. These tests contain open questions for which a wide range of solutions are possible. For example, the

respondent may be asked to list some creative uses for an everyday object such as a brick. Responses are scored according to criteria that measure their quantity (number of ideas) and quality (originality of the ideas).

Research indicates that a high level of creativity requires an above-average level of intelligence, but once a 'threshold' level of intelligence is reached (in about the top 10% of the general population), personality factors become more important. Psychologists define personality in terms of five core traits (the 'Big Five'): Openness to experience, conscientiousness, extraversion, agreeableness and neuroticism. Each trait varies independently along a dimension between two extremes (e.g. introverted versus extraverted). There seems to be a close link between creativity and one aspect of personality: Higher levels of creativity are particularly associated with a high level of openness to experience, involving a preference for variety, intellectual curiosity, attentiveness to feelings, an active imagination and high aesthetic sensitivity. By and large the same personality traits are associated with high-level creativity in both artists and scientists, though artists are apparently distinguished more by their emotional instability than are scientists. Neuroimaging studies indicate that the prefrontal cortex is particularly important for creative thinking. This brain area (discussed in Chapter 2) is involved in the control and organisation of attention, memory and idea generation.

Can computers be creative? It is fairly straightforward to develop a computer algorithm to create artworks that look superficially identical to those made by certain Modernist artists. Figure 7.1 is a montage of images that I made using algorithms which generate the motifs of several well-known artists. An intentional element of random variation in the output of the algorithms makes each image unique. For example, the selection of colours in most of the images is random (within well-defined constraints). However, the algorithms and their output images cannot make any grand claims about creativity. They follow recipes for rendering tightly constrained images. The creativity resides primarily in the artists who devised the original motifs (and,

Figure 7.1 A montage of six computer-generated images that recreate motifs of six well-known Modern artists, made using simple computer algorithms. The motifs represent works by Elsworth Kelly, Jackson Pollock, Bridget Riley, Damien Hirst, Frank Stella and Francois Morellet.

to some extent, in the design of the algorithms that generate variations on those motifs).

Recent developments in artificial intelligence (AI) have led some scientists to argue that computers *can* be creative. Modern AI systems use 'deep neural networks' that are inspired by the dense, multi-levelled networks of neurons in real brains. These artificial networks can be trained to learn complex new tasks, such as to recognise particular objects in camera images (though it is unclear how exactly the networks learn). A recent system that is claimed to be capable of "generating art with creative characteristics" uses two neural networks that work as adversaries (Elgammal et al., 2017). One network – the 'generator' – knows nothing about art but generates new instances of candidate 'art' images from random starting points. The other network – the 'discriminator' – has been trained to recognise real artworks in a large number of styles (Renaissance, Baroque, Impressionist and so on). The discriminator classifies each output of the generator as 'art' or

'not art' according to whether the output fits within the bounds of known styles, feeds this classification back to the generator, and the generator then produces a new instance of art for assessment. This adversarial system eventually converges on novel 'art' images based on

> optimising a criterion that maximizes stylistic ambiguity while staying within the art distribution (Elgammal et al., 2017).

In an online experiment, a majority of human spectators rated some of the art as having been created by an artist. Eighty-five percent of computer art generated by the system in the Abstract Expressionist style was attributed to a human artist. These results are impressive. The developers of the system argue that it satisfies several criteria for creativity: It has

> the ability to produce novel artifacts (imagination), the ability to generate quality artifacts (skill), and the ability to assess its own creation (Elgammal et al., 2017).

However, the system falls short in several respects. As the authors themselves acknowledge, the system has no understanding of the different styles, or what the paintings mean to human viewers. It just learns how to generate instances of art that optimise a defined quantitative criterion. The art generated by the system must conform to styles defined by past art, in a similar though admittedly much more sophisticated way to the art in Figure 7.1. However, some of the most creative and important artworks ever produced are so significant because at the time they *violated* accepted notions of what is art. Impressionism was initially ridiculed as vulgar and crude. Impressionist paintings broke the accepted artistic rules of the French Academy of Fine Arts and were rejected from its annual exhibition. Louis Leroy, the critic who coined the term Impressionism, wrote that

> Wallpaper in its embryonic state is more finished!

Duchamp's urinal (Figure 1.2) fell well outside the bounds of what people considered acceptable as art, and is considered to be one of the most important artworks ever created because of the way that it questioned established belief structures and values. Aside from creativity, a defining feature of genuine art mentioned in the previous chapter is its capacity to convey emotion. It is difficult to imagine that computer-generated art could ever reach a stage where spectators would knowingly be happy to attribute emotional expression to it. Ultimately, what is 'creative' and 'artistic' can only be defined by humans.

BEYOND CREATIVITY

A capacity for high-level creative thinking is an important prerequisite for success both as an artist and a scientist. However, success involves much more than creativity. Persistence, obsessiveness and competitiveness are also important. Persistence is needed because both artists and scientists must expose their work to the (sometimes savage) gaze of their peers and patrons. As you read earlier, esteem indicators for art include the number of visitors to gallery exhibitions, the prestige of the galleries themselves and the monetary value of the commissions and sale prices that the artworks attract. The corresponding esteem indicators for scientific output include the number of times a research article is read or cited by other researchers (citation counting is a huge business in modern science), the prestige of the journal in which the article is published (competition is high to publish in journals with a high 'impact factor') and the monetary value of research awards won by the scientist from funding bodies. On the downside, when the creative juices begin to dry up, both artists and scientists may continue to pursue a particular motif, technique or research paradigm well beyond the point at which it continues to offer new insights and perspectives in their respective disciplines. Shelf-life is limited, whatever the discipline. With a few rare exceptions (Darwin and Einstein being the most obvious examples), the work of a scientist is destined to be superseded by new

theories, paradigms or techniques which take us ever closer to the ultimate 'truth' behind a particular scientific question, without ever quite reaching that Holy Grail.

It almost goes without saying that the best artists and scientists are hugely committed, disciplined and dedicated to their profession, to an extent that borders on obsession. Pablo Picasso is thought to have produced about 50,000 artworks in his lifetime. J.M.W. Turner is estimated to have left behind nearly 33,000 works, most of them on paper. Both artists and scientists naturally tend to become more specialist as their skills and career develop. The specialism can be either technical or formal. Among artists, technical specialisation may involve, for example, the use of a particular technique for creating artworks, such as drip painting (Jackson Pollock), or the use of a particular medium such as oil. For scientists, technical specialisation takes the form of expertise in particular kinds of laboratory equipment or technologies such as neuroimaging, or eye movement recording or computational modelling. Formal specialisation can involve a focus on certain artistic forms, such as the human body (Anthony Gormley) or scientific issues, such as black holes (Stephen Hawking).

As discussed early in the book, artists and scientists are highly competitive people, but are often reluctant to admit as much. For scientists, the race is often for priority – to publish a new finding or theory before anyone else. The Holy Grail for a scientist is to publish a new theory or finding that creates and entirely new research field. For artists, the competition is for your work to achieve higher esteem, fame and value than the art of your peers. The Holy Grail is to create a new art movement or genre.

There are some differences between artistic and scientific careers, of course. The products of artistic practice are traditionally more accessible to non-specialists than the outputs of scientific practice (though Modern and Post-Modern art can be rather inscrutable unless the artist or gallery has supplied some explanatory text). Although attending art college is the most common way to embark on a career, it is possible, although extremely difficult, to become a successful

full-time artist without having attended art college. Leonardo and van Gogh lacked any substantial degree of formal training in art. Leonardo lived at a time when art schools did not even exist (the first Italian art schools were founded in the late 1500s, 50 years after Leonardo's death). Nor did he attend university. Leonardo did, however, receive some training as an apprentice in the studio of Andrea del Verrocchio. Vincent van Gogh's formal education ended at the age of 15, and he taught himself to paint over a period of five years in his mid-twenties (he was, though, a professional art dealer before turning to painting). On the other hand, it is virtually impossible in the Modern era to become a full-time scientist without having completed some formal training in science beforehand. The term 'outsider scientist' is something of a misnomer, as it is used to refer to someone who was trained in a field outside of the scientific discipline in which they eventually work. The molecular biologist Francis Crick, for example, was jointly awarded a Nobel Prize in 1962 for his role in the discovery of the structure of the DNA molecule, but in later life he turned his attention to the neuroscience of consciousness.

Most artists practice their art by running their own studio, perhaps employing some assistants if they have a large practice. Well-known artists such as Damien Hirst, Geoff Koons and Olafur Eliasson may employ 100 or more assistants in their studio. Scientists are generally employed to work in universities or specialist research organisations, though they often maintain a laboratory that employs large numbers of assistants.

Both artists and scientists must handle the constant pressure to produce new work. For an artist, the pressure may come from the gallery, eager for new work to display in an exhibition, which will be seen, judged by their peers and ultimately bought by carefully selected collectors. Their reputation, income and ability to pay their assistants all depend on the quality of their ideas and concepts, and how well they are executed. For a scientist, their position itself (if it is a fixed-term one) or career prospects (if they have a tenured position), as well as those of their assistants, depend on securing research support from a funding body in the face of very stiff competition

from other scientists, then executing the research and finally publishing the results in highly-respected peer-reviewed journals. In both fields, creativity and originality ultimately must be put in the service of income-generation.

It is perhaps not surprising that the practices and careers of high-level artists and scientists are so closely related, given that the goal of both is to create new knowledge about the world, and about us as humans.

FURTHER READING

CHAPTER 1

To read more about research on how visitors view art in galleries, see Carbon (2017). A brief introduction to Gustav Fechner's psychophysics can be found at: https://digest.bps.org.uk/2007/04/20/an-introduction-to-psychophysics/ Some of the most common myths in folk psychology are described in Lilienfeld et al. (2010). To read the article by Alva Noe that is quoted in the chapter, see Alva Noe (2011). Grayson Perry's book (2014) was based on his series of BBC Reith Lectures. It is a highly entertaining and informative read. You can listen to the lectures themselves at: www.bbc.co.uk/programmes/b03969vt For a detailed account of the presentation styles used in the exhibition of African art at the Centre for African Art in New York in 1988, and their effects on visitors, see Faris (1988). A detailed academic discussion of the Hawthorne effect in psychology can be found at: www.psy.gla.ac.uk/~steve/hawth.html Little (2004) offers an informative, brief guide to the major -isms in visual art, and Hampton (2012) provides a good review of the psychology of concepts. To read an accessible, brief history of Western art, see Kemp (2014).

CHAPTER 2

To read more about the debate concerning scientific approaches to art, see Zeki (1999), Hutton and Kelly (2013), Pearce et al. (2016) and Bullot (2019).

A TED Talk by Semir Zeki on beauty and the brain can be found at: www. youtube.com/watch?v=NlzanAw0RP4

See Cavanagh (2005) to read an accessible account of the close links between neuroscience and art. Research findings on handedness in brains and behaviour are described in Lanthony (1995), Corballis (2014) and van der Feen et al. (2019). To read some clinical case studies of the effect of brain damage on art, see Cohen et al. (1994), Wapner et al. (1978), Mendez (2004) and Rankin et al. (2007). Research on the role of large-scale brain networks in art can be found in Ellamil et al. (2012) and Vessel et al. (2012). The brain areas involved in aesthetic judgements are investigated in Ishizu and Zeki (2013) and Vartanian and Skov (2014). The quote about the brain's reward system can be found in Montague and Berns (2002), while 'core affects' are discussed in Barrett et al. (2006).

CHAPTER 3

An accessible video introduction to Darwin's theory of evolution can be found at: www.youtube.com/watch?v=hOfRN0KihOU

The estimate of the time take for an eye to evolve from scratch was taken from Nilsson and Pelger (1994). Debates about evolution and art can be found in Dutton (2010) and Pinker (1997). Gould (1991) discusses the concept of exaptation. Denis Dutton's TED Talk on beauty (complete with drawings) can be found at: www.youtube.com/watch?v=PktUzdnBqWI

The distinction between ultimate and proximate explanations is discussed in Scott-Phillips et al. (2011). Play in animals is discussed by Burghardt (2014), and fitness indicators in animals are discussed by Schaedelin and Taborsky (2009). For articles on the fitness theory of art, see Miller (2001), Clegg et al. (2011), Nettle and Clegg (2006) and Kaufman et al. (2014).

A brief BBC natural history video of bowerbirds, narrated by David Attenborough, can be viewed at: www.youtube.com/watch?v=GPbWJPsBPdA

Paris (2017) offers a modern perspective on psychoanalytical approaches to mental health. Many of the points made about the status of psychoanalysis also apply in the context of art. Nesse (1990) discusses evolutionary explanations of emotions, if you are interested in reading more about this. See Kidd and Hayden (2015) to read more about the psychology and neuroscience of curiosity.

CHAPTER 4

Many of the quotes from artists in this chapter and others are taken from Chipp (1968), which is a collection of first-hand accounts by artists of the ideas behind their artistic practice. This website focuses on the artists working during the time that Modernism emerged in Europe: www.theartstory.org/definition/modern-art/history-and-concepts/

The quote in the text by Robert Pepperell is taken from Pepperell (2017). To read more about the structure of the eye and brain, and their relation to sensation and perception, see Mather (2016). Ittelson (1951) is a classic and rare experimental study of the use of angular size in judgements of object distance. This chapter does not discuss ophthalmological conditions affecting the eyes and art. Marmor and Ravin's (2009) book covers the impact of many ocular conditions, such as eye disease and cataract. The quote from Erwin Panofsky comes from Pirenne (1952), which also contains more details on linear perspective. A detailed scholarly account of the history of perspective can be found in Kemp (1990). Vishwanath et al. (2005) report a scientific study of the apparent distortion (or lack of distortion) seen in pictures when they are viewed from a position away from the centre-of-projection. Rogers and Naumenko (2016) measured the apparent curvature seen in very long straight lines, whereas Pepperell and Haertel (2014) studied the extent to which artistic depictions of space depart from the rules of linear perspective. A forensic analysis of the sfumato technique used by Leonardo was reported in Elias and Cotte (2008). The artist David Hockney's copiously illustrated book (Hockney, 2001), arguing that many Old Masters used optical aids in their work, is worth a read if you are interested in this area (there are many YouTube videos based on the book too). To read more about line drawings and the brain, see Sayim and Cavanagh (2011). Scientific articles on theories of object representation can be found in Marr and Nishihara (1978), Biederman (1987), Ullman (1989) and Hummel (2013). An introduction to fractals is available at this website: https://fractalfoundation.org/resources/what-are-fractals/

A discussion of the application of fractals and other mathematical measures to art can be found in Mather (2014a), while more detailed scientific treatments can be found in Mandelbrot (1967), Párraga et al. (2000), Graham and Redies (2010), Taylor et al. (1999) and Mather (2018).

CHAPTER 5

If you would like to read more about the science of colour vision, Solomon and Lennie (2007) provide a detailed summary of contemporary knowledge. Kemp (1990) surveys the history of the use of colour in European art. Mollon (2006) tells the story of Gaspard Monge's contribution to colour science, as well as his place in French science alongside Chevreul. The account of unique hues in the 14th-century windows of the Alhambra can be found in Pridmore (2006). Forder et al. (2017) report some recent research on the nature of the unique hues. An interesting historical account of the role of horses in 19th-century French culture can be found in Mayer (2010). Galton's explanation for the flying gallop pose was published in Galton (1882). A brief account of the impact of Muybridge's photographs can be found at: www.tate.org.uk/tate-etc/issue-20-autumn-2010/moving-times

A BBC documentary on Muybridge can be watched here: www.youtube.com/watch?v=5Awo-P3t4Ho

MoMA still has a comprehensive website devoted to the 1965 Responsive Eye exhibition, including downloadable copies of press releases and the exhibition catalogue: www.moma.org/calendar/exhibitions/2914

A grainy black-and-white film about the exhibition can be viewed at: www.youtube.com/watch?v=vaUme6DY8Lk

Mackay's shimmering image was published in Mackay (1957). To read a detailed account of how Fourier Analysis applies to human vision, see Westheimer (2001). Zanker and Walker (2004) give an account of how they used 'riloid' patterns to investigate the illusory movements seen in Op Art style images, while Murakami et al. (2006) take a different approach to these illusions. One of the authors of the latter paper, Akiyoshi Kitaoka, maintains a website that contains many excellent examples of Op Art style images: www.ritsumei.ac.jp/~akitaoka/index-e.html

CHAPTER 6

To read more about research on facial beauty, see Cunningham et al. (1995). To read more about the 'prospect and refuge' theory of landscape preference, see Appleton (1996). Semir Zeki discusses Clive Bell's notion of 'significant form' from the perspective of neuroscience in Zeki (2013). Rule and Levine's

essay on International Art English can be read at: www.canopycanopycanopy.com/contents/international-art-english-ebook

A longer discussion of sensory and decision factors in perceptual judgements can be found in Chapter 7 of Mather (2014b). A detailed account of van Meegeren's career as a forger can be found in Wynne (2006). More about van Meegeren can also be read at: www.essentialvermeer.com/misc/van_meegeren.html and www.bbc.co.uk/programmes/profiles/2r60JJtpKg07SzyZ9FTpSZP/han-van-meegeren-1889-1947

The definition of connoisseurship used in the text was given in Bellingham (2012). The neuroimaging research on judgements of authenticity can be found in Huang et al. (2011). A newspaper report about the dispute concerning Titian's Danae can be read here: www.theguardian.com/artanddesign/2019/oct/19/authenticity-of-major-titian-the-danae-challenged

To read more about research on the effect of viewing original art in a gallery as opposed to reproductions a laboratory, see Brieber et al. (2015), Grüner et al. (2019), Locher and Dolese (2004) and Locher et al. (2001). The quote from Robert Hughes was taken from Hughes (1990); this book contains a celebrated collection of thought-provoking essays on art and artists. To read more about awe and sublimity, see Keltner and Haidt (2003), and for research on the effect of size see Pelowski et al. (2017) and Seidel and Prinz (2018). The analysis of the colour gamut of reproductions in the National Gallery was reported in MacDonald and Morovič (1995). To read more about sex as a factor in auction sales, see McMillan (2019). Nochlin (1971) offers a pioneering essay on women in art, raising questions about art history and sex that are still relevant today. To read some recent research on sex and art, see Adams et al. (2017), Goldin and Rouse (2000) and MacNell et al. (2015).

CHAPTER 7

Arno Minkkinen's metaphorical story about finding an artistic vision can be found at: https://petapixel.com/2013/03/13/the-helsinki-bus-station-theory-finding-your-own-vision-in-photography/

To read more about Margaret Boden's take on creativity, see Boden (2010). Research on the intelligence and personality factors that bear on creativity was reported in Jauk et al. (2013) and Feist (1998). The neuroimaging study of creativity was reported in Pidgeon et al. (2016). Elgammal et al. (2017)

developed the deep neural network that, they argue, can create new artworks. In this video, mathematician Marcus de Sautoy discusses AI approaches to creativity, including deep neural networks, based on his book *The Creativity Code*: www.youtube.com/watch?v=k89sS6fsZvI

'Outsider scientists' are discussed by Harman and Dietrich (2013).

BIBLIOGRAPHY

Adams, R. B., Krrussl, R., Navone, M. A., and Verwijmeren, P. (2017). Is gender in the eye of the beholder? Identifying cultural attitudes with art auction prices. *SSRN Electronic Journal*, (December). https://doi.org/10.2139/ssrn.3083500

Alva Noe. (2011). Art and the limits of neuroscience. *The New York Times*. Retrieved from http://opinionator.blogs.nytimes.com/2011/12/04/art-and-the-limits-of-neuroscience/?_r=0

Appleton, J. (1996). *The Experience of Landscape*. New York: Wiley.

Barrett, L. F., Mesquita, B., Ochsner, K. N., and Gross, J. J. (2006). The experience of emotion. *Annual Review of Psychology*, 58, 373–403. https://doi.org/10.1146/annurev.psych.58.110405.085709

Bellingham, D. (2012). Attribution and the market: The case of Frans Hals. In M. Aldrich and J. Hackford-Jones (Eds.), *Art and Authenticity* (pp. 22–36). Farnham: Lund Humphries.

Biederman, I. (1987). Recognition-by-components: A theory of human image understanding. *Psychological Review*, 94(2), 115–147.

Boden, M. A. (2010). *Creativity and Art: Three Roads to Surprise*. Oxford: Oxford University Press.

Brieber, D., Nadal, M., and Leder, H. (2015). In the white cube: Museum context enhances the valuation and memory of art. *Acta Psychologica*, 154, 36–42. https://doi.org/10.1016/j.actpsy.2014.11.004

Bullot, N. J. (2019). A psychohistorical philosophy for the science of the arts. In *On Art and Science* (pp. 223–245). https://doi.org/10.1007/978-3-030-27577-8_14

Burghardt, G. M. (2014). Play in fishes, frogs and reptiles. *Current Biology*, 25(1), R9–R10. https://doi.org/10.1111/eth.12312

Carbon, C.-C. (2017). Art perception in the museum: How we spend time and space in art exhibitions. *i-Perception*, 8(1).

Cavanagh, P. (2005). The artist as neuroscientist. *Nature*, 434(7031), 301–307. https://doi.org/10.1038/434301a

Chipp, H. B. (1968). *Theories of Modern Art: A Source Book for Artists and Critics*. University of California Press.

Clegg, H., Nettle, D., and Miell, D. (2011). Status and mating success amongst visual artists. *Frontiers in Psychology*, 2(October). https://doi.org/10.3389/fpsyg.2011.00310

Cohen, L., Gray, F., Meyrignac, C., Dehaene, S., and Degos, J. D. (1994). Selective deficit of visual size perception: Two cases of hemimicropsia. *Journal of Neurology, Neurosurgery & Psychiatry*, 57(1), 73–78. https://doi.org/10.1136/jnnp.57.1.73

Corballis, M. C. (2014). Left brain, right brain: Facts and fantasies. *PLoS Biology*, 12(1). https://doi.org/10.1371/journal.pbio.1001767

Cunningham, M. R., Roberts, A. R., Barbee, A. P., Druen, P. B., and Wu, C. H. (1995). "Their ideas of beauty are, on the whole, the same as ours": Consistency and variability in the cross-cultural perception of female physical attractiveness. *Journal of Personality and Social Psychology*, 68(2), 261–279. https://doi.org/10.1037/0022-3514.68.2.261

Cutting, J. E. (2003). Gustave Caillebotte, French impressionism, and mere exposure. *Psychonomic Bulletin & Review*, 10(2), 319–343. Retrieved from www.ncbi.nlm.nih.gov/pubmed/12921411

Dutton, D. (2010). *The Art Instinct*. London: Bloomsbury Press.

Elgammal, A., Liu, B., Elhoseiny, M., and Mazzone, M. (2017). *CAN: Creative adversarial networks, generating "Art" by learning about styles and deviating from style norms*. Retrieved from http://arxiv.org/abs/1706.07068

Elias, M., and Cotte, P. (2008). Multispectral camera and radiative transfer equation used to depict Leonardo's sfumato in Mona Lisa. *Applied Optics*, 47(12), 2146–2154. https://doi.org/10.1364/AO.47.002146

Ellamil, M., Dobson, C., Beeman, M., and Christoff, K. (2012). Evaluative and generative modes of thought during the creative process. *NeuroImage*, 59(2), 1783–1794. https://doi.org/10.1016/j.neuroimage.2011.08.008

Faris, J. C. (1988). "ART/artifact": On the museum and anthropology. *Current Anthropology*, 29(5), 775–779.

Feist, G. J. (1998). A meta-analysis of personality in scientific and artistic creativity. *Personality and Social Psychology Review*, 2(4), 290–309. https://doi.org/10.1207/s15327957pspr0204_5

Forder, L., Bosten, J., He, X., and Franklin, A. (2017). A neural signature of the unique hues. *Scientific Reports*, 7(1), 1–8. Retrieved from www.nature.com/articles/srep42364

Galton, F. (1882). Conventional representation of the horse in motion. *Nature*, 26(662), 228–229. https://doi.org/10.1038/026228a0

Gibson, J. J. (1950). *The Perception of the Visual World*. Boston, Houghton Mifflin.

Goldin, C., and Rouse, C. (2000). Orchestrating impartiality: The impact of "blind" auditions on female musicians. *American Economic Review*, 90(4), 715–741. https://doi.org/10.1257/aer.90.4.715

Gould, S. J. (1991). Exaptation: A crucial tool for an evolutionary psychology. *Journal of Social Issues*, 47(3), 43–65. https://doi.org/10.1111/j.1540-4560.1991.tb01822.x

Graham, D. J., and Redies, C. (2010). Statistical regularities in art: Relations with visual coding and perception. *Vision Research*, 50(16), 1503–1509. https://doi.org/10.1016/j.visres.2010.05.002

Grüner, S., Specker, E., and Leder, H. (2019). Effects of context and genuineness in the experience of art. *Empirical Studies of the Arts*, 37(2), 138–152. https://doi.org/10.1177/0276237418822896

Hampton, J. A. (2012). Thinking intuitively: The rich (and at times illogical) world of concepts. *Current Directions in Psychological Science*, 21(6), 398–402. https://doi.org/10.1177/0963721412457364

Harman, O., and Dietrich, M. R. (Eds.). (2013). *Outsider Scientists: Routes to Innovation in Biology*. Chicago: University of Chicago Press.

Hering, E. (1964). *Outlines of a theory of the light sense*. Harvard University Press.

Hockney, D. (2001). *Secret Knowledge: Rediscovering the Lost Techniques of the Old Masters*. London: Thames & Hudson.

Huang, M., Bridge, H., Kemp, M. J., and Parker, A. J. (2011). Human cortical activity evoked by the assignment of authenticity when viewing works of art. *Frontiers in Human Neuroscience*, 5(November), 1–9. https://doi.org/10.3389/fnhum.2011.00134

Hughes, R. (1990). *Nothing if Not Critical: Selected Essays on Art and Artists*. London: The Harvill Press.

Hummel, J. E. (2013). Object recognition. In D. Reisburg (Ed.), *Oxford Handbook of Cognitive Psychology* (pp. 32–46). Oxford University Press.

Hutton, N., and Kelly, L. (2013). Where lines are drawn. *Science*, 341(September), 1453–1454.

Ishizu, T., and Zeki, S. (2013). The brain's specialized systems for aesthetic and perceptual judgment. *European Journal of Neuroscience*, 37(9), 1413–1420. https://doi.org/10.1111/ejn.12135

Ittelson, W. H. (1951). Size as a cue to distance: Static localization. *The American Journal of Psychology*, 64(1), 54–67. https://doi.org/10.2307/1418595

Jauk, E., Benedek, M., Dunst, B., and Neubauer, A. C. (2013). The relationship between intelligence and creativity: New support for the threshold hypothesis by means of empirical breakpoint detection. *Intelligence*, 41(4), 212–221. https://doi.org/10.1016/j.intell.2013.03.003

Kaufman, S. C., Kozbelt, A., Silvia, P., Kaufman, J. C., Ramesh, S., and Feist, J. G. (2014). Who finds Bill Gates sexy? Creative mate preferences as a function of cognitive ability, personality, and creative achievement. *Journal of Creative Behavior*, 50(4), 294–307. https://doi.org/10.1002/jocb.78

Keltner, D., and Haidt, J. (2003). Approaching awe, a moral, spiritual, and aesthetic emotion. *Cognition and Emotion*, 17(2), 297–314. https://doi.org/10.1080/02699930244000318

Kemp, M. (1990). *The Science of Art: Optical Themes in Western Art from Brunelleschi to Seurat.* New Haven: Yale University Press.

Kemp, M. (2014). *Art in History.* London: Profile Books.

Kidd, C., and Hayden, B. Y. (2015). The psychology and neuroscience of curiosity. *Neuron*, 88(3), 449–460. https://doi.org/10.1016/j.neuron.2015.09.010

Lanthony, P. (1995). Les peintres gauchers. *Revue Neurologique*, 151(3), 165–170.

Lilienfeld, S. O., Lynn, S. J., Ruscio, J., and Beyerstein, B. L. (2010). The top ten myths of popular psychology. *Skeptic Magazine*, 15(3), 36–43.

Little, S. (2004). *-isms: Understanding Art.* London: Bloomsbury.

Locher, P. J., and Dolese, M. (2004). A comparison of the perceived pictorial and aesthetic qualities of original paintings and their postcard images. *Empirical Studies of the Arts*, 22(2), 129–142. https://doi.org/10.2190/eqtc-09lf-jrha-xkjt

Locher, P. J., Smith, J. K., and Smith, L. F. (2001). The influence of presentation format and viewer training in the visual arts on the perception of pictorial

and aesthetic qualities of paintings. *Perception*, 30(4), 449–465. https://doi.org/10.1068/p3008

MacDonald, L., and Morovič, J. (1995). Assessing the effects of gamut compression in the reproduction of fine art paintings. *Final Program and Proceedings – IS and T/SID Color Imaging Conference*, 194–200.

Mackay, D. M. (1957). Moving visual images produced by regular stationary patterns. *Nature*, 180, 849–850. Retrieved from https://link.springer.com/content/pdf/10.1038/181362c0.pdf

MacNell, L., Driscoll, A., and Hunt, A. N. (2015). What's in a name: Exposing gender bias in student ratings of teaching. *Innovative Higher Education*, 40(4), 291–303. https://doi.org/10.1007/s10755-014-9313-4

Mandelbrot, B. B. (1967). How long is the coast of Britain? Statistical self-similarity and fractional dimension. *Science*, 156(3775), 636–638.

Marmor, M. F., and Ravin, J. G. (2009). *The Artist's Eyes: Vision and the History of Art.* New York: Abrams.

Marr, D., and Nishihara, H. K. (1978). Representation and recognition of the spatial organization of three-dimensional shapes. *Proceedings of the Royal Society of London B*, 200(1140), 269–294. https://doi.org/10.1098/rspb.1978.0020

Mather, G. (2014a). *Essentials of Sensation and Perception.* London: Routledge. https://doi.org/10.4324/9781315787275

Mather, G. (2014b). *The Psychology of Visual Art: Eye, Brain and Art.* Cambridge: Cambridge University Press.

Mather, G. (2016). *Foundations of Sensation and Perception* (3rd ed.). London: Routledge. https://doi.org/10.4324/9781315672236

Mather, G. (2018). Visual image statistics in the history of western art. *Art and Perception*, 6(2–3), 97–115. https://doi.org/10.1163/22134913-20181092

Mayer, A. (2010). The physiological circus: Knowing, representing, and training horses in motion in nineteenth-century France. *Representations*, 111(Summer), 88–120. Retrieved from https://rep.ucpress.edu/content/111/1/88.short

McMillan, K. (2019). *Representation of Female Artists in Britain during 2018.* Retrieved from www.freelandsfoundation.co.uk/research/representation-of-female-artists-in-britain-2018

Mendez, M. F. (2004). Dementia as a window to the neurology of art. *Medical Hypotheses*, 63(1), 1–7. https://doi.org/10.1016/j.mehy.2004.03.002

Miller, G. F. (2001). Aesthetic fitness: How sexual selection shaped artistic virtuosity as a fitness indicator and aesthetic preferences as mate choice criteria. *Bulletin of Psychology and the Arts*, 2(2001), 20–25. Retrieved from www.unm.edu/~gfmiller/new_papers2/miller 2001 aesthetic.doc

Mollon, J. (2006). Monge: The Verriest lecture, Lyon, July 2005. *Visual Neuroscience*, 23, 297–309.

Montague, P. R., and Berns, G. S. (2002). Neural economics and the biological substrates of valuation. *Neuron*, 36(2), 265–284. Retrieved from www.ncbi.nlm.nih.gov/pubmed/12383781

Murakami, I., Kitaoka, A., and Ashida, H. (2006). A positive correlation between fixation instability and the strength of illusory motion in a static display. *Vision Research*, 46(15), 2421–2431. https://doi.org/10.1016/j.visres.2006.01.030

Nesse, R. M. (1990). Evolutionary explanations of emotions. *Human Nature*, 1(3), 261–289.

Nettle, D., and Clegg, H. (2006). Schizotypy, creativity and mating success in humans. *Proceedings of the Royal Society B*, 273(1586), 611–615. https://doi.org/10.1098/rspb.2005.3349

Nilsson, D. E., and Pelger, S. (1994). A pessimistic estimate of the time required for an eye to evolve. *Proceedings of the Royal Society B*, 256(1345), 53–58. https://doi.org/10.1098/rspb.1994.0048

Nochlin, L. (1971). Why have there been no great women artists? In *The Feminism and Visual Culture Reader* (pp. 229–233).

Paris, J. (2017). Is psychoanalysis still relevant to psychiatry? *Canadian Journal of Psychiatry*, 62(5), 308–312. https://doi.org/10.1177/0706743717692306

Párraga, C. A., Troscianko, T., and Tolhurst, D. J. (2000). The human visual system is optimised for processing the spatial information in natural visual images. *Current Biology*, 10(1), 35–38. Retrieved from www.ncbi.nlm.nih.gov/pubmed/10660301

Pearce, M. T., Zaidel, D. W., Vartanian, O., Skov, M., Leder, H., Chatterjee, A., and Nadal, M. (2016). Neuroaesthetics: The cognitive neuroscience of aesthetic experience. *Perspectives on Psychological Science*, 11(2), 265–279. https://doi.org/10.1177/1745691615621274

Pelowski, M., Forster, M., Tinio, P. P. L., Scholl, M., and Leder, H. (2017). Beyond the lab: An examination of key factors influencing interaction with "Real" and museum-based art. *Psychology of Aesthetics, Creativity, and the Arts*, 11(3), 245–264. https://doi.org/10.1037/aca0000141

Pepperell, R. (2017). Imaging human vision: An artistic perspective. IS&T *International Symposium on Electronic Imaging, Human Vision and Electronic Imaging*, 261–267.

Pepperell, R., and Haertel, M. (2014). Do artists use linear perspective to depict visual space? *Perception*, 43(5), 395–416.

Perry, G. (2014). *Playing to the Gallery*. London: Penguin.

Pidgeon, L. M., Grealy, M., Duffy, A. H. B., Hay, L., McTeague, C., Vuletic, T., . . . Gilbert, S. J. (2016). Functional neuroimaging of visual creativity: A systematic review and meta-analysis. *Brain and Behavior*, 6, e00540. https://doi.org/10.1002/brb3.540

Pinker, S. (1997). *How the Mind Works*. New York: W.W. Norton.

Pirenne, M. H. (1952). The scientific basis of Leonardo da Vinci's theory of perspective. *The British Journal for the Philosophy of Science*, 3(10), 169–185.

Pridmore, R. W. (2006). 14th century example of the four unique hues. *Color Research and Application*, 31(4), 364–365. https://doi.org/10.1002/col.20229

Rankin, K. P., Liu, A. A, Howard, S., Slama, H., Hou, C. E., Shuster, K., and Miller, B. L. (2007). A case-controlled study of altered visual art production in Alzheimer's and FTLD. *Cognitive and Behavioral Neurology*, 20(1), 48–61. https://doi.org/10.1097/WNN.0b013e31803141dd

Rogers, B. J., and Naumenko, O. (2016). Perception of straightness and parallelism with minimal distance information. *Attention, Perception, & Psychophysics*, 1381–1391. https://doi.org/10.3758/s13414-016-1083-x

Sayim, B., and Cavanagh, P. (2011). What line drawings reveal about the visual brain. *Frontiers in Human Neuroscience*, 5(October), 118. https://doi.org/10.3389/fnhum.2011.00118

Schaedelin, F. C., and Taborsky, M. (2009). Extended phenotypes as signals. *Biological Reviews*, 84, 293–313. https://doi.org/10.1111/j.1469-185X.2008.00075.x

Scott-Phillips, T. C., Dickins, T. E., and West, S. A. (2011). Evolutionary theory and the ultimate-proximate distinction in the human behavioral sciences. *Perspectives on Psychological Science*, 6(1), 38–47. https://doi.org/10.1177/1745691610393528

Seidel, A., and Prinz, J. (2018). Great works: A reciprocal relationship between spatial magnitudes and aesthetic judgment. *Psychology of Aesthetics, Creativity, and the Arts*, 12(1), 2–10. https://doi.org/10.1037/aca0000100

Solomon, S. G., and Lennie, P. (2007). The machinery of colour vision. *Nature Reviews Neuroscience*, 8(4), 276–286. https://doi.org/10.1038/nrn2094

Taylor, R. P., Micolich, A., and Jonas, D. (1999). Fractal analysis of Pollock's drip paintings. *Nature*, 399(June), 422. Retrieved from www.mag.keio.ac.jp/~asako/Aethetics/03June1999pollock.doc

Ullman, S. (1989). Aligning pictorial descriptions: An approach to object recognition. *Cognition*, 32(3), 193–254. https://doi.org/10.1016/0010-0277(89)90036-X

van der Feen, F. E., Zickert, N., Groothuis, T. G. G., and Geuze, R. H. (2019). Does hand skill asymmetry relate to creativity, developmental and health issues and aggression as markers of fitness? *Laterality*, 1–34. https://doi.org/10.1080/1357650X.2019.1619750

Vartanian, O., and Skov, M. (2014). Neural correlates of viewing paintings: Evidence from a quantitative meta-analysis of functional magnetic resonance imaging data. *Brain and Cognition*, 87(1), 52–56. https://doi.org/10.1016/j.bandc.2014.03.004

Vessel, E. a, Starr, G. G., and Rubin, N. (2012). The brain on art: Intense aesthetic experience activates the default mode network. *Frontiers in Human Neuroscience*, 6(April), 1–17. https://doi.org/10.3389/fnhum.2012.00066

Vishwanath, D., Girshick, A. R., and Banks, M. S. (2005). Why pictures look right when viewed from the wrong place. *Nature Neuroscience*, 8(10), 1401–1410. https://doi.org/10.1038/nn1553

Wapner, W., Judd, T., and Gardner, H. (1978). Visual agnosia in an artist. *Cortex*, 14(3), 343–364. https://doi.org/10.1016/S0010-9452(78)80062-8

Westheimer, G. (2001). The Fourier theory of vision. *Perception*, 30(5), 531–541. https://doi.org/10.1068/p3193

Wynne, F. (2006). *I Was Vermeer: The Forger Who Swindled the Nazis*. London: Bloomsbury Press.

Zanker, J. M., and Walker, R. (2004). A new look at op art: Towards a simple explanation of illusory motion. *Naturwissenschaften*, 91(April), 149–156. https://doi.org/10.1007/s00114-004-0511-2

Zeki, S. (1999). Art and the brain. *Journal of Consciousness Studies*, 6(6–7), 76–96.

Zeki, S. (2013). Clive Bell's "Significant Form" and the neurobiology of aesthetics. *Frontiers in Human Neuroscience*, 7(November), 1–14. https://doi.org/10.3389/fnhum.2013.00730